POSTCARD HISTORY SERIES

Fayetteville and Fort Bragg

IN VINTAGE POSTCARDS

POSTCARD HISTORY SERIES

Fayetteville and Fort Bragg

IN VINTAGE POSTCARDS

Cumberland County Historical Society Inc.

ARCADIA
PUBLISHING

Published by Arcadia Publishing
Charleston SC, Chicago IL, Portsmouth NH, San Francisco CA

Printed in the United States of America

Library of Congress Catalog Card Number: 2001095916

For all general information contact Arcadia Publishing at:
Telephone 843-853-2070
Fax 843-853-0044
E-Mail sales@arcadiapublishing.com
For customer service and orders:
Toll-Free 1-888-313-2665

Visit us on the Internet at www.arcadiapublishing.com

CONTENTS

ACKNOWLEDGMENTS

This collection is a labor of love by members of the Cumberland County Historical Society Inc., several of whom are avid collectors of postcard views of Fayetteville and Fort Bragg. Larry Tew conceived the idea and guided the project. A selection committee including Tew, Katherine Lewis, Eddie Durako, Clarence Winstead, and Roy Parker Jr. gathered the cards and chose from among a rich array dating from the earliest days of postcard photography.

In addition to Tew, Durako, Winstead, and Parker, other collectors who graciously offered choice items from their collections were Ken Suggs, Manfred and Sonia Rothstein, and John and Jerry Gimmish. The Special Collections Library of Duke University provided a key portion of the images, especially those of the Cape Fear River flood in 1908.

The captions were written by Roy Parker Jr.

The real heroes of the collection are those photographers, many whose names are unfortunately lost to history, who for more than a century past aimed their cameras at the people and scenes of Fayetteville and Fort Bragg. They left us an enduring treasure of images, a storehouse of historical information. We believe this collection of their work will be a valuable historical resource for the community that is now nearly 250 years old and the military post that observes its 84th birthday in 2002.

INTRODUCTION

Modern Fayetteville is a city of over 100,000 in an urban area of over 300,000. But for most of its nearly 250-year history, it was a village or modest town.

The history of Fayetteville told in postcard views is largely the story of its earlier days, before World War II wrought its transformation from courthouse and textile mill town to modest metropolis.

The transformation also took place at Fort Bragg. Built in 1918 as a cantonment designed for thousands of Army artillerymen, but not finished before World War I ended, the military reservation just down the road from the town was home to a complement of a few thousand soldiers until World War II when, within a year, it grew to be a military city of nearly 70,000 men and women in uniform.

Fayetteville's history began in the mid-18th century when John Newberry, a Pennsylvania Quaker and millwright, built a waterwheel grist mill on a strategic site where two colonial wagon roads converged at a stream known as Cross Creek, a mile from a swampy boat landing on the Cape Fear River.

The settlement that grew up around the site of his mill took the name of the creek. By the beginning of the War of Independence, the village of mills, stores, taverns, a tanyard, a brewery, and a county jail was, despite its tiny size, nonetheless the most populous inland town in North Carolina. After the War of Independence, the village was laid out in a grid of streets and squares, and became the county seat of Cumberland County. And Cross Creek took a new name. It was the first place in North America named for the Marquis deLafayette, the young French hero of the war.

Most of the first postcards of Fayetteville, several dating from as early as 1906, depict views of this old town, with its streets radiating off the Market Square, where an 18th-century structure was replaced in 1832 by today's notable Market House, one of North Carolina's most familiar urban landmarks.

In the early 20th century, many streets which today are lined with commercial buildings were leafy residential thoroughfares. Much of the commercial center of the city was built in the 1920s and 1930s, and still retains the architectural flavor of those decades.

Unusual in a sprawling modern city, the genesis site of Fayetteville is still discernible in this older part of town. Cross Creek still flows through the downtown district, and even today, water still flows over a later dam at the site of John Newberry's original mill. The site is now in the shadow of Fayetteville's tallest building.

In the early 20th century, in the first days of the postcard, a mill and its millpond still stood at the site. This picturesque scene was a favorite of early postcard photographers. Their views were

in the tradition of the earliest known image of Fayetteville, a painting of 1816 depicting "mill-dam at Fayetteville."

In the heyday of the postcard, Fayetteville's churches, hospitals, and educational institutions were well covered in postcard photography. First Presbyterian Church and St. John's Episcopal Church dated from the early 19th century. The 1890s saw the construction of handsome Gothic Revival structures for downtown Baptist and Methodist churches. Highsmith Hospital, among North Carolina's first "modern" hospitals, was first on Market Square in downtown Fayetteville, and later on the high tableland west of the town known as Haymount. Postcards provide the only visual information about such vanished early schools as the 1858 "female high school," which remained on Hay Street until the 1920s, and of Aycock Hall, built in 1908 as the first state-financed structure on the campus of what is today Fayetteville State University.

Postcard photography got a tremendous boost in 1908 when the Cape Fear River flooded much of downtown Fayetteville. Albums and collections of the many views of the unforgettable event became treasured family heirlooms in Fayetteville households.

Postcards were a favorite advertising medium for hotels, motels, tourist homes, tourist camps, and eating establishments. Beginning in the 1920s and the 1930s as rail and highway travel provided an expanding flow of customers, Fayetteville offered a rich array of such places. After World War II, postcards remained a favorite form of advertising at stops along busy north-south highway corridors.

Fort Bragg's postcard history began in the 1930s, when rows of dilapidated wooden buildings were replaced with permanent brick buildings, including barracks, a hospital, headquarters, and handsome neighborhoods of bungalow quarters for officers and noncommissioned officers and their families.

In the period of the brightly-colored mailer card, Pope Field, the Army Air Corps installation affiliated with Bragg, also provided views of planes and balloons supplementing the views of big guns, horse-drawn howitzers, and marching formations of the artillerymen.

World War II brought hundreds of thousands of American men and women to Fort Bragg, and they used postcards to tell their stories to the folks back home. Wartime cards depicted the "old post," and also the thousands of new buildings where so many bunked while training for battlefronts of the world. They also pictured the everyday activity of the troops, with views of mess halls, recreation centers, and training grounds. Postcards from this period are postmarked from every corner of the country, and their messages often convey a vivid sense of what young Americans were doing and saying in a wartime that touched everyone.

Postwar Fort Bragg became the "Home of the Airborne," and a new generation of postcard views depicted the colorful training of paratroopers of the 82nd Airborne Division and of the Special Forces soldiers, the famed Green Berets. With Pope Air Force Base, where big transport airplanes are ready to fly to the four corners of the world, the military community of the former artillery cantonment in the sandhills comprises nearly 50,000 men and women in uniform.

———Roy Parker Jr.
Fayetteville, North Carolina, 2001

One

OLD CENTER OF
NEW FAYETTEVILLE

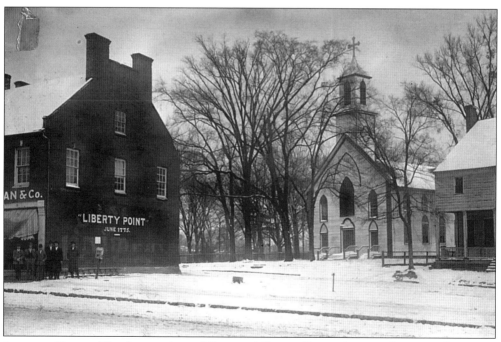

LIBERTY POINT. The intersection of Bow and Person Streets is one of Fayetteville's oldest locations, dating from colonial days. In August of 1775, at a tavern probably located on this site, 58 patriots signed a defiant anti-British petition later known as "the Liberty Point Resolves." To the right is the first Catholic church in North Carolina, which dated from 1832 and was on the site for more than a century.

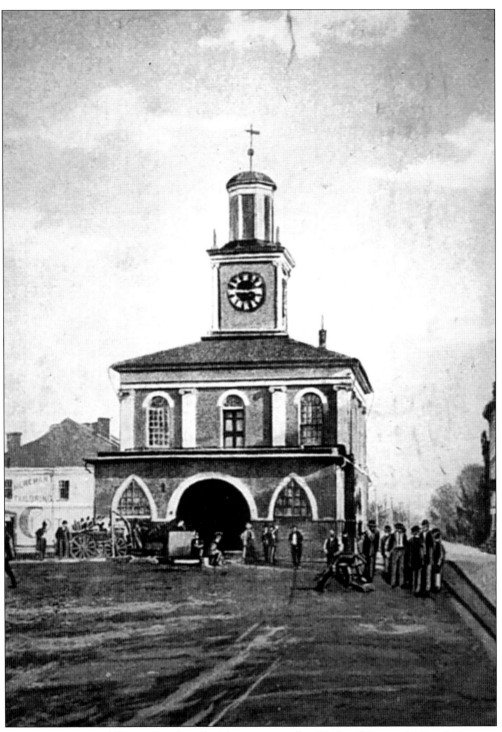

MARKET HOUSE. This early view looking east at the Market House depicts it in one of the many paint schemes used over the years, with the lower arches glassed in. (Courtesy of Roy Parker Jr.)

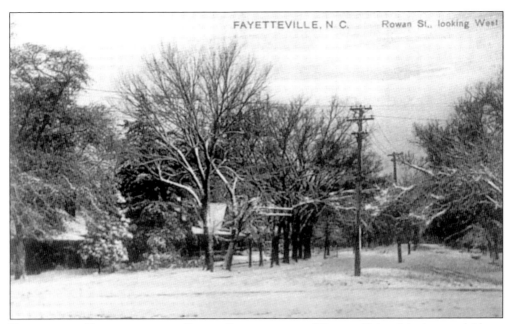

RESIDENTIAL THOROUGHFARE. Rowan Street was one of Fayetteville's original streets laid out in 1783. It was named for Col. Robert Rowan, the town's leading Revolutionary War personality. Until the 1950s, it was a principal residential street. This turn-of-the-century view depicts a rare snow scene and illustrates the handsome elm tree border that lined nearly every street in those days. (Courtesy of Special Collections Library, Duke University.)

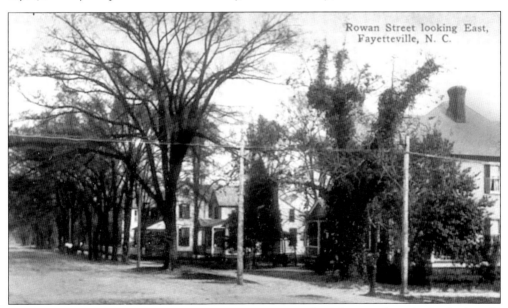

LEADING CITIZENS' HOMES. Rowan Street was a residential street from its beginnings in the 1780s. By the early 20th century, the south side of the thoroughfare was lined with typical homes of the well-to-do. As of 2001, only a single structure remains dating from the time of this picture. It is restored and used for business offices. (Courtesy of Special Collections Library, Duke University.)

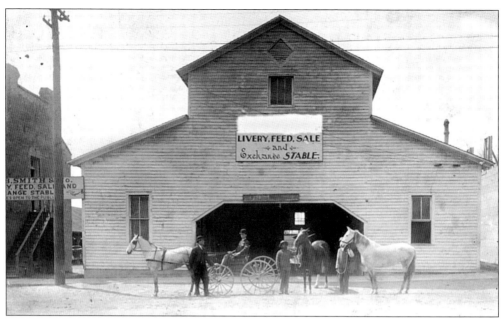

THE MULE CAPITAL. By the early 1900s, Fayetteville was a center of trade in mules, the indispensable animal of cotton agriculture. This is Bevill's Mule Barn on Gillespie Street. Bevill advertised that he bought Missouri mules in lots of 500. The structure and its surrounding pens were razed in the 1920s as the site for Cumberland County's sixth courthouse. (Courtesy of Roy Parker Jr.)

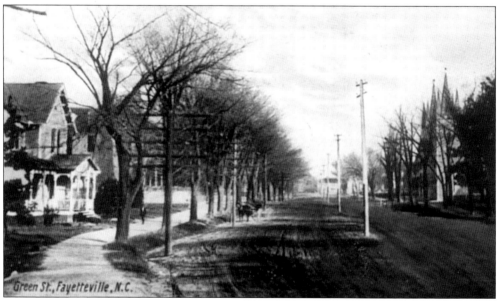

LOOKING NORTH. In the early 20th century, Green Street was unpaved, as this view clearly shows. The first electricity in the town was delivered along lines erected in the middle of the main streets. This winter view looks north towards the fourth Cumberland County courthouse, which stood in the intersection of Green, Rowan, Ramsey, and Grove Streets. (Courtesy of Special Collections Library, Duke University.)

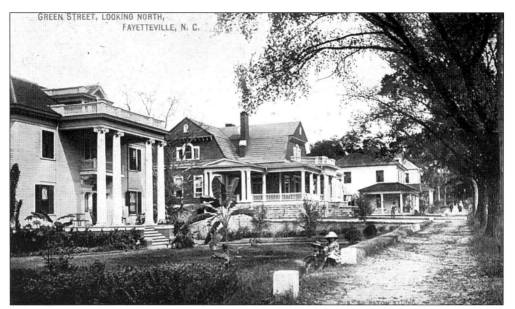

GREEN STREET. Fayetteville's oldest commercial thoroughfare was a portion of the so-called colonial "King's Road." In this early 20th-century view, the west side of the street was lined with handsome homes of the town's leading merchants and professional men. This scene depicts the first block north of Cross Creek. (Courtesy of Clarence Winstead.)

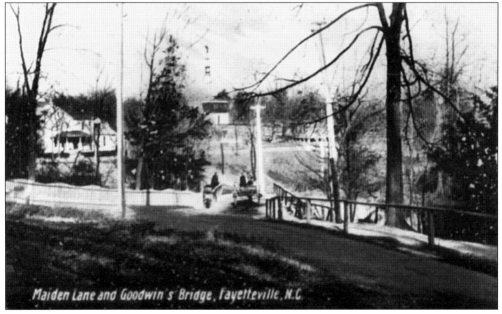

MAIDEN LANE. Named just before the American Revolution, Maiden Lane was the first street in the colonial village of Cross Creek to be purposely laid out and given a name. In 1778, the county's third courthouse stood at the corner of Maiden Lane and present-day Ray Avenue. This early 20th-century view shows the handsome residential character of the street then. (Courtesy of Special Collections Library, Duke University.)

13

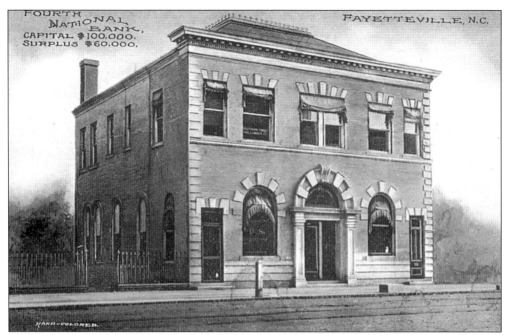

NATIONAL BANK. The Fourth National Bank building, located two doors from Donaldson Street on the north side of Hay, was an architectural ornament of the commercial heart of Fayetteville in the early 20th century. Fayetteville was an early antebellum banking center and included a branch of the United States Bank. (Courtesy of Clarence Winstead.)

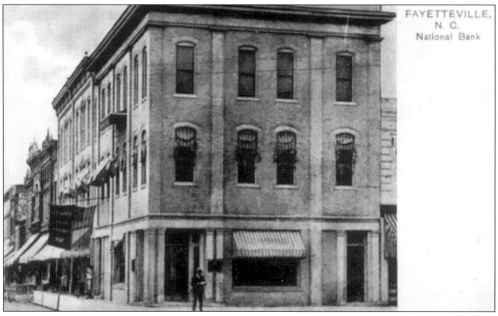

FEDERAL BANK. In the early 20th century, the building of the National Bank of Fayetteville, organized in 1900, stood at the corner of Hay and Green Streets. This view shows the Green Street facade. Hay Street is around the corner to the left. (Courtesy of Special Collections Library, Duke University.)

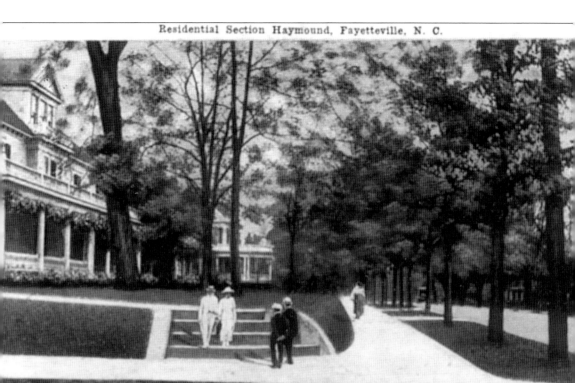

ON HAYMOUNT. The hillside just west of early Fayetteville was named Haymount in 1784 by its owner, lawyer-legislator John Hay. It was from its beginning a favored residential neighborhood. This early 20th-century view depicts the corner of Hay Street (right) and Fountainhead Lane, where Highsmith Hospital would be built in 1926. (Special Collections Library, Duke University.)

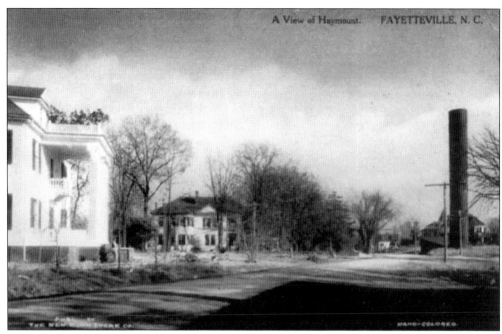

HAYMOUNT LANDMARK. A cylindrical municipal water tower was an early 20th-century landmark on Haymount. It stood on Hay Street just west of the original Highland Presbyterian Church, built in 1913, which can be seen behind it in this view. (Special Collections Library, Duke University.)

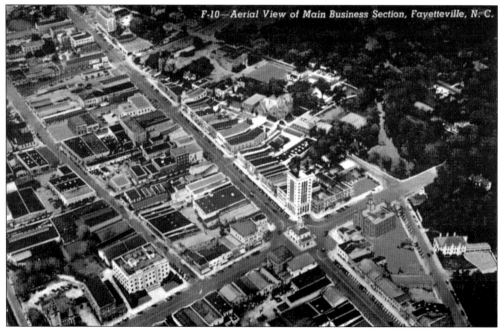

FROM THE AIR. Aerial views of Fayetteville began in 1919 when Army flyers from Pope Field at Camp Bragg aimed cameras from their observation planes. This is an aerial from the middle of the 20th century. (Courtesy of Larry Tew.)

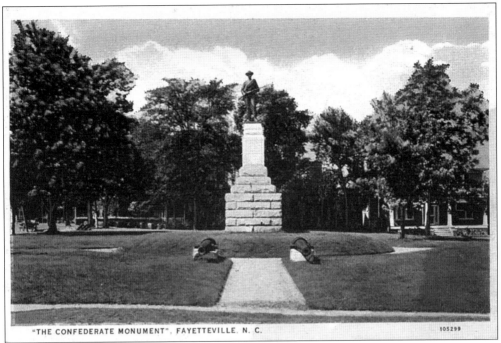

CONFEDERATE MONUMENT. A Confederate Monument Association was organized in Fayetteville within months after the surrender at Appomattox in 1865. In 1894, the monument was erected at the intersection of Ramsey, Green, Grove, and Rowan Streets, on the site of a recently-razed courthouse that had been there for over a century. (Courtesy of Clarence Winstead.)

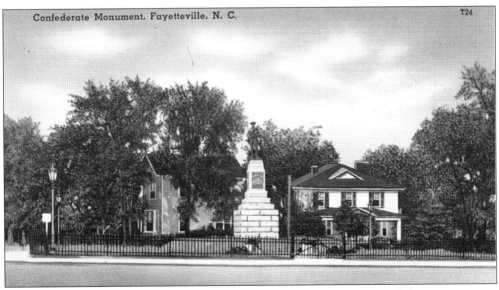

TRAFFIC CIRCLE. Within a few years, automobile traffic around the Confederate monument site necessitated a fence and sidewalk. In the 1950s, the monument was moved to the side of the street. The large frame house, dating from the Civil War, was also moved and became a golf course clubhouse in Moore County. (Courtesy of Clarence Winstead.)

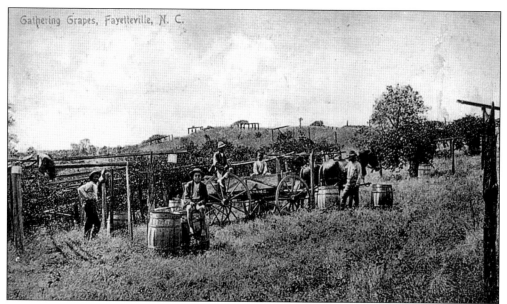

GRAPE CULTURE. Commercial grape-growing began in the Fayetteville area in the decades before the Civil War and was revived after the war. In the 1880s, the Tokay vineyards north of the town were a well-known producer of grapes for wine. This view probably depicts the Tokay operation. A somewhat later vineyard southeast of the town was known as Bordeaux. (Courtesy of Clarence Winstead.)

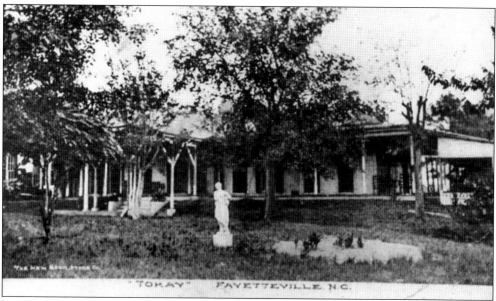

TOKAY MANSION. The owner of Tokay vineyards, Col. Wharton J. Green, presided at this sprawling country house north of Fayetteville after 1880. Green was a Confederate veteran and congressman who moved to Cumberland County after the Civil War and revived antebellum grape-growing operations. The home was the scene of balls and elaborate receptions, most notably upon the marriage of his daughter Sarah to Pembroke Jones in 1884. (Courtesy of Special Collections Library, Duke University.)

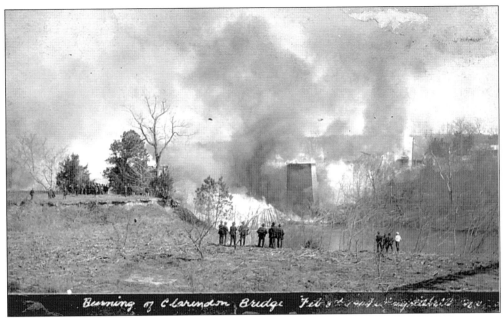

Burning of Clarendon Bridge

CLARENDON FIRE. The wooden bridge across the Cape Fear known as Clarendon Bridge was consumed by a slow fire February 3 and 4, 1909. A local photographer made a series of views as the structure smoldered and then collapsed. The bridge was a copy of the original Clarendon, built in 1819 and destroyed in 1865 by retreating Confederate troops. (Courtesy of Roy Parker Jr.)

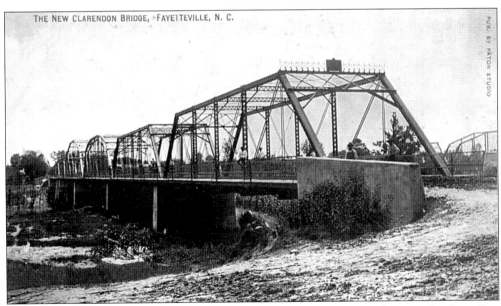

THE NEW CLARENDON BRIDGE, FAYETTEVILLE, N. C.

PUB. BY PATON STUDIO

STEEL BRIDGE. When a 19th-century single-span wooden covered bridge over the Cape Fear burned in 1908, it was replaced with this up-to-date steel structure. The first bridge at the site, known as the Clarendon Bridge, was built in 1819 by Ithiel Town, the inventor of the "Town Truss" design. The second wooden covered bridge was burned by retreating Confederates in 1865. (Courtesy of Clarence Winstead.)

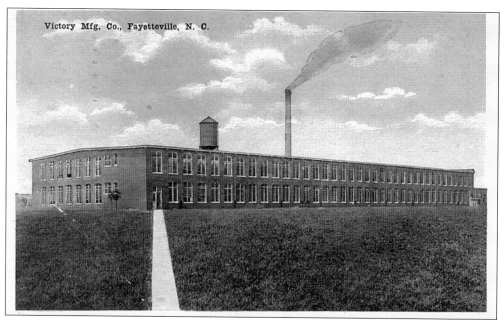

TEXTILE TOWN. Fayetteville was a center of textile manufacturing beginning in the early 1830s. In the late 19th century, a half-dozen cotton factories employed most of the community's workers. The Victory Mill was part of an array of operations in the Massey Hill community and was built in the early 20th century. (Courtesy of Roy Parker Jr.)

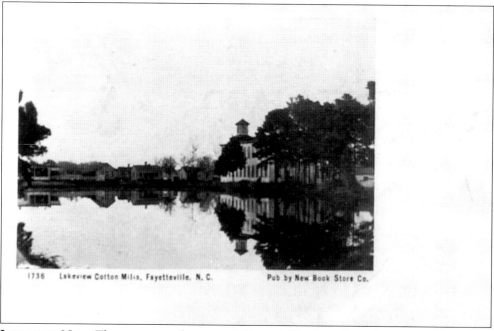

LAKEVIEW MILL. The cotton textile town of Hopes Mills dates from the 1830s, when it was known as Rockfish Mill and Village. Lakeview Cotton Mills was an early 20th-century operation in Hope Mills. (Courtesy of Special Collections Library, Duke University.)

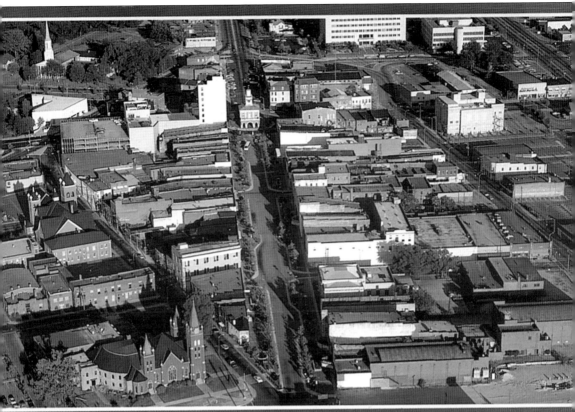

Greetings from Fayetteville, NC

NEW COURTHOUSE. This aerial view looks east along Hay Street and is notable for the new Cumberland County courthouse in the far background. (Courtesy of Manfred and Sonia Rothstein.)

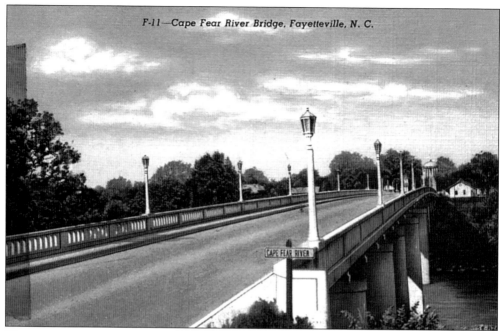

F-11—Cape Fear River Bridge, Fayetteville, N. C.

HONORING VETERANS. By the 1930s, the Cape Fear River bridge carried the traffic of a major north-south highway. Money from the New Deal helped pay for a modern bridge, embellished with handsome lighting fixtures. The bridge was dedicated in 1938 and honored veterans of World War I. (Courtesy of Clarence Winstead.)

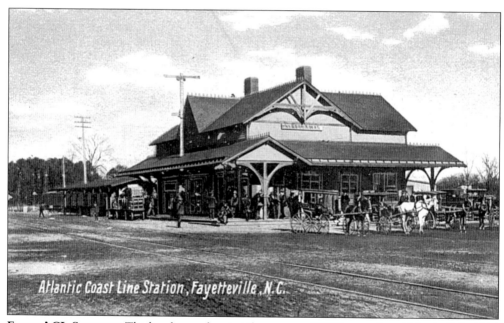

Atlantic Coast Line Station, Fayetteville, N.C.

FIRST ACL STATION. The handsome depot at the corner of Hillsborough and Hay, built in 1893 by the Atlantic Coastline Railroad, ushered in the heyday of passenger train service in Fayetteville. The card, which looks north along the AC tracks, was printed in Germany and is one of the earliest postcard views of the community. (Courtesy of Roy Parker Jr.)

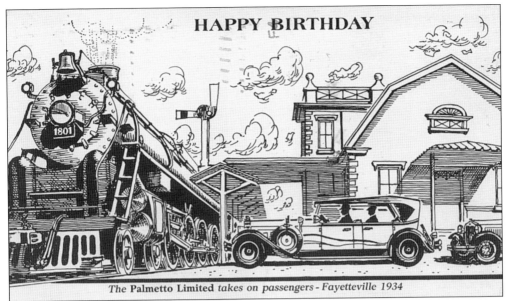

The Palmetto Limited *takes on passengers - Fayetteville 1934*

PALMETTO LIMITED. This modern rendering, used as a birthday greeting postcard, provides a grand view of the ACL depot in its 20th century glory days, when such famous trains as the New York-to-Florida passenger train known as the Palmetto Limited made its stops. At its peak, 30 passenger trains made daily stops in Fayetteville. (Courtesy of Roy Parker Jr.)

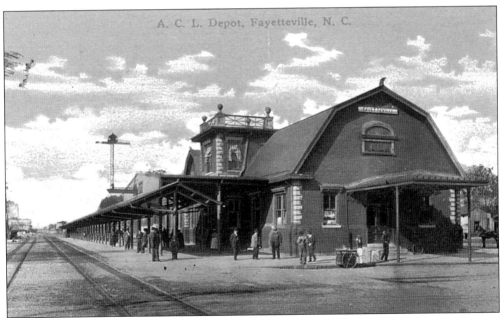

SECOND ACL STATION. In 1911, the original ACL station was replaced with this larger depot of Dutch Colonial style architecture. By then, the original single track had been joined by another, and a depot signal tower had replaced the line of telephone poles. The structure is still in use today. Owned by the city, it includes both the Amtrak station and a leased fast-food shop. (Courtesy of Larry Tew.)

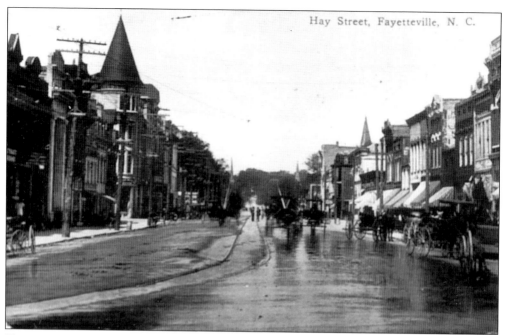

Hay Street, Fayetteville, N. C.

TROLLEY TRACKS. A steam trolley system operated along Hay Street briefly in the years before the World War I. This scene clearly shows the tracks.

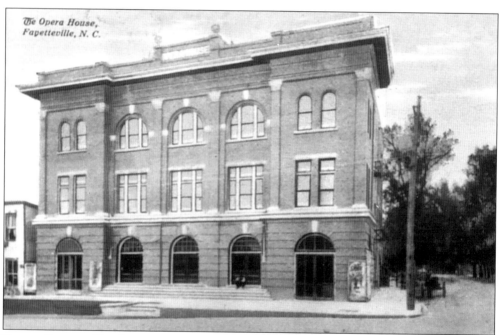

The Opera House,
Fayetteville, N. C.

FANCY FACADE. First known as the Opera House, later the LaFayette Auditorium, this imposing structure at the corner of Person and Dick Streets was the pride of the town when it went up in 1908. It later served as a market and a motion picture theater. It burned in 1950. (Courtesy of Special Collections Library, Duke University.)

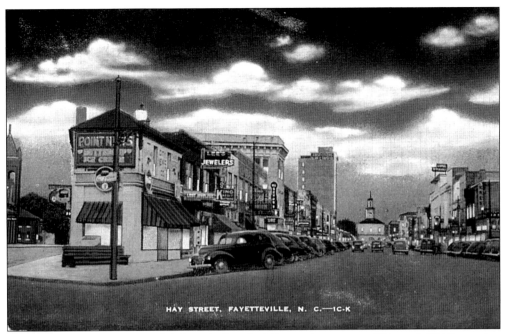

POINT NEWS. A much-remodeled antebellum building at the corner of Hay and Old Streets has been called Point News for more than 60 years. This 1930s scene is in the heyday of neon store signs on Hay Street. (Courtesy of Clarence Winstead.)

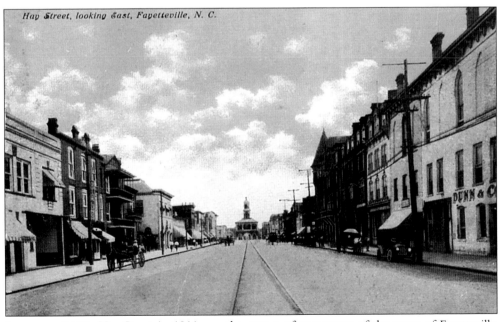

LOOKING EAST. Hay Street in 1911 was the center of commerce of the town of Fayetteville, lined with storefronts in its first two blocks west from the Market House. Farther out, there remained many open spaces, punctuated by smaller residential and commercial structures, several of which dated from antebellum days, as well as the new ACL depot and the new U.S. Post Office. (Courtesy of John and Jerry Gimish.)

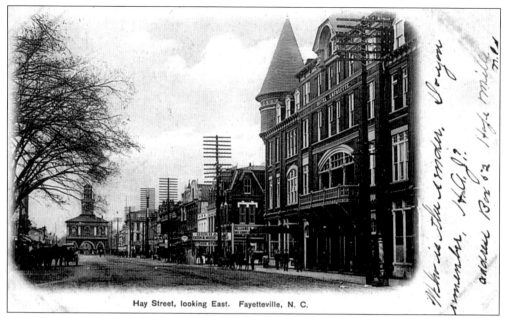

Hay Street, looking East. Fayetteville, N. C.

LAFAYETTE HOTEL. This earliest of Hay Street views looks east past the tower of the Lafayette Hotel, which was built in 1885 at the corner of Donaldson Street and Hay. The heyday of above-ground power and telephone lines is depicted in this card dated 1906. (Courtesy of Manfred and Sonia Rothstein.)

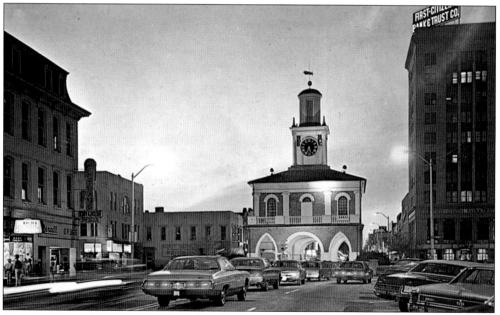

NIGHT SCENE. In World War II and until the 1970s, downtown was a nighttime mecca for Fayettevilleans and soldiers from Fort Bragg, with four motion picture theaters, including the modern Colony on Hay Street, and various streets lined with shops, cafes, and stores. And downtown had the traffic to prove it, as this early evening scene around the Market House shows. (Courtesy of Roy Parker Jr.)

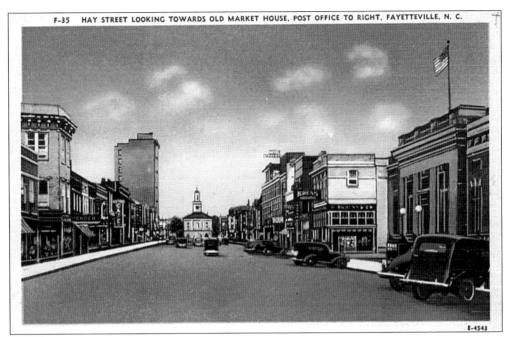

BUSINESS ROW. A 1930s view towards the east along Hay Street starts at the post office on the right, with a skyline dominated by the First Citizens Bank building. This building, which opened at the corner of Hay and Green in 1926, is still Fayetteville's tallest building. (Courtesy of Clarence Winstead.)

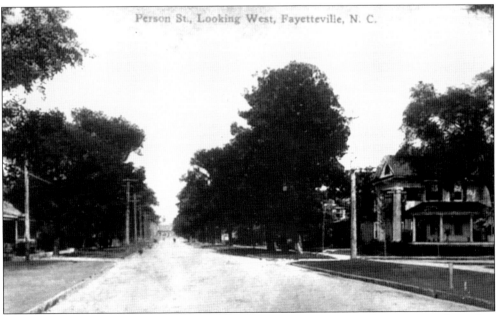

PERSON STREET. In the early years of the 20th century, the border of mature trees framed an array of handsome residences, and the newly installed granite curbstones set off the dirt street from the trees and sidewalks. The trees were cut down in the 1950s when the street was widened. (Courtesy of Special Collections Library, Duke University.)

27

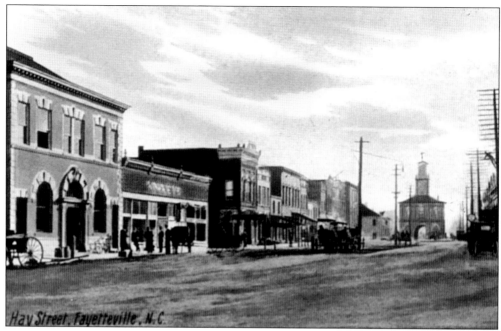

HAY STREET. Laid out in 1783, Hay Street was named for John Hay, one of the legislators named to lay out Fayetteville in a regular grid pattern. This early view of the street looks east to the Market House. (Courtesy of Special Collections Library, Duke University.)

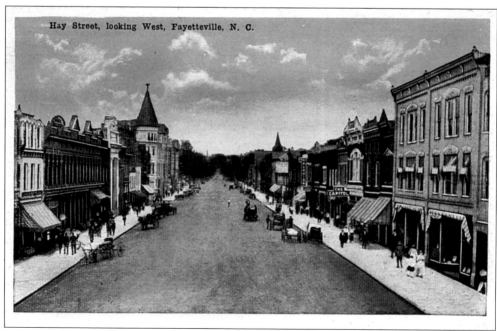

LOOKING WEST. This view looks west up Hay Street, showing the busy commercial days of the early 20th century, when horse-drawn vehicles dominated the transportation scene. (Courtesy of Clarence Winstead.)

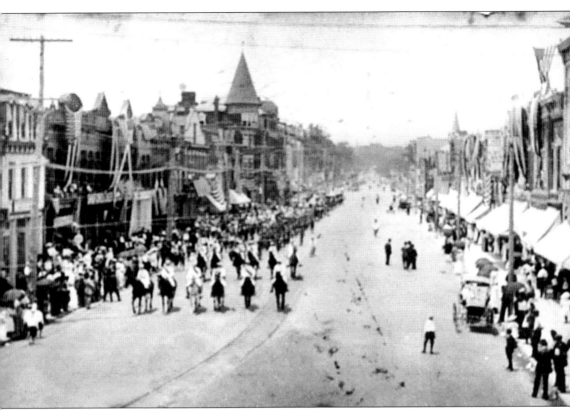

PARADE ROUTE. Hay Street was always a favorite for parades. This one in the early 20th century features horse riders and a early automobile. (Courtesy of Special Collections Library, Duke University.)

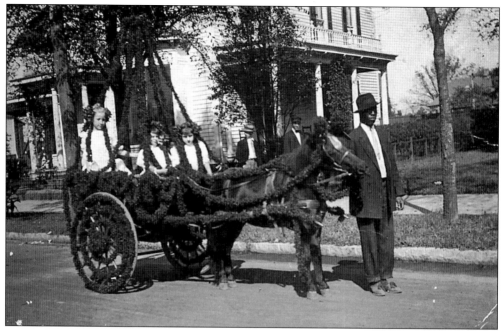

CHILDREN'S PARADE. A big feature of the 1911 Fourth of July parade in Fayetteville was the lineup of pony carts with children as passengers. This flower-covered entry set the pattern, with three young ladies all dressed in white. A notation on the card says "Inez Hunter Smith." (Courtesy of Roy Parker Jr.)

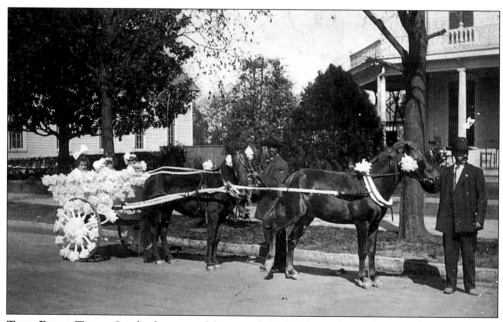

TWO-PONY TEAM. Surely the most elaborate of the 1911 parade entries was this team of two ponies hitched to a two-wheel pony cart bedecked with bouquets from axle to rim and even on the ears of the ponies. Note that both the entries have black men as trainers and grooms. (Courtesy of Roy Parker Jr.)

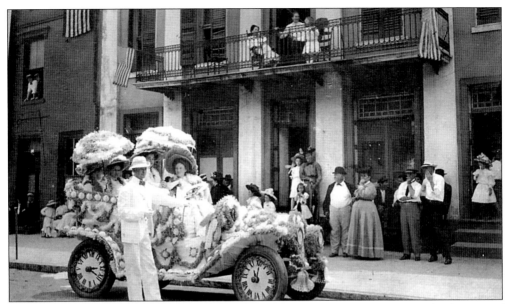

AUTO FINERY. One of Fayetteville's earliest automobiles is somewhere under all the bunting of this entry in the parade of 1911. Notice the elaborate clock faces on the wheels. The crowd in the background is gathered on the street and the balcony of the Overbaugh Hotel on the east side of the first block of Green Street. (Courtesy of Roy Parker Jr.)

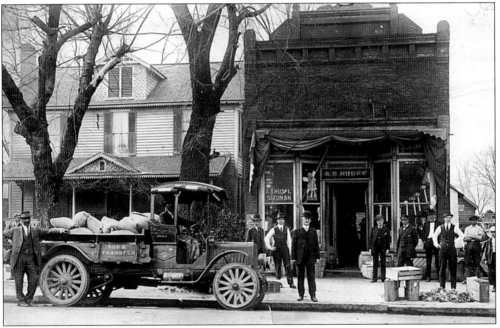

BUSINESS LEADER. The mercantile operations of the Huske family were a dominant part of the Fayetteville economy at the turn of the 20th century. This *c.* 1911 view shows the company's earliest store on Hay Street. Mr. A.S. Huske is in the center of this lineup in front of the store on which a window sign identifies him as "A.S. Huske, Seedman." The sign on the side of the truck advertises it as a "bus and transfer." (Courtesy of Roy Parker Jr.)

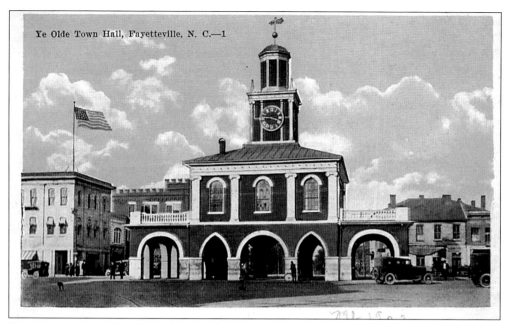

THE DISPENSARY. Notable in this view looking north towards the Market House is the building on the left, flying a big U.S. flag. During an early form of liquor control, spirits were sold from a single "dispensary" store, located in this building. The card is dated 1923, however, after full Prohibition had arrived. (Courtesy of Roy Parker Jr.)

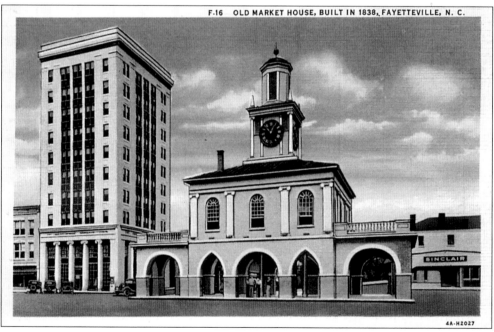

F-16 OLD MARKET HOUSE, BUILT IN 1838, FAYETTEVILLE, N. C.

CUMBERLAND NATIONAL. The dispensary corner of Market Square, northwest of the Market House, was the site for what continues as Fayetteville's tallest building, the ten-story skyscraper of the Cumberland National Bank, built in 1926. Its upper stories were offices for lawyers, insurance salesmen, and a tailor shop. (Courtesy of Roy Parker Jr.)

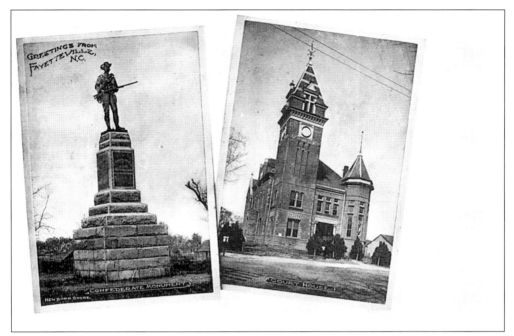

TWO VIEWS FOR ONE. This card from the early 20th century combines two others published by the New Book Store. At the time, both the Confederate monument and the 1894 courthouse were notable new additions to the town's landscape. (Courtesy of Roy Parker Jr.)

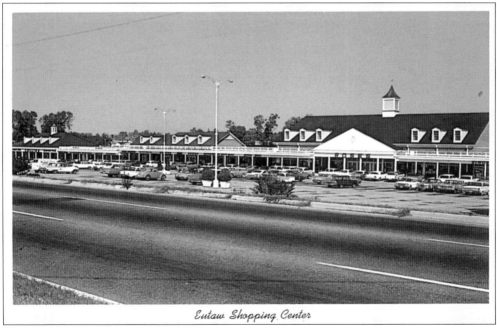

Eutaw Shopping Center

FIRST MALL. Fayetteville's first major shopping mall, harbinger of its growth to big-city size after World War II, is the 1950s Eutaw Shopping Center. It was a centerpiece of Bragg Boulevard, the first modern thoroughfare connecting the older town with Fort Bragg. This is a first-year view. (Courtesy of Roy Parker Jr.)

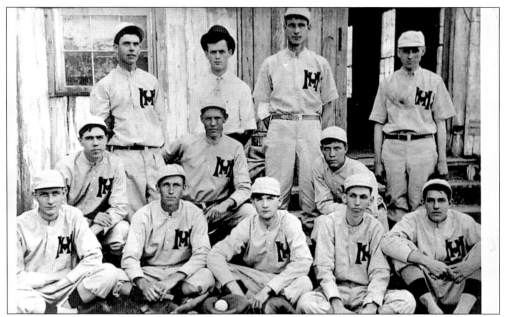

BASEBALL FRENZY. In a town where the fabled Babe Ruth hit his first major league home run 1914 (during a Baltimore Oriole training game), baseball was Fayetteville's most popular sport in the early 20th century. This is the team of the Holt-Morgan textile factory, one of three mill village nines in the Massey Hill neighborhood. (Courtesy of Roy Parker Jr.)

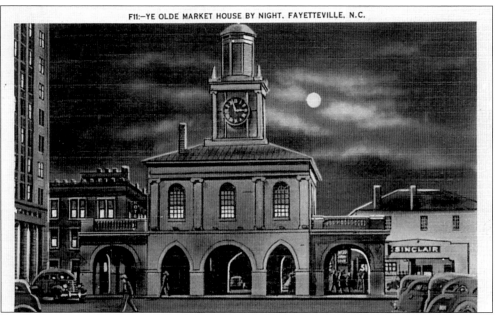

MOONLIT NIGHT. After-dark scenes in urban areas were popular postcard subjects, and the Market House is featured in a veritable gallery of such views. This one from the late 1920s is noteworthy for the lights shining from the windows of Highsmith Hospital in the left background, as well as the busy scene around the filling station on the northeast corner at the right—a Market Square landmark for 20 years. (Courtesy of Roy Parker Jr.)

Two

The Dam and Where It Began

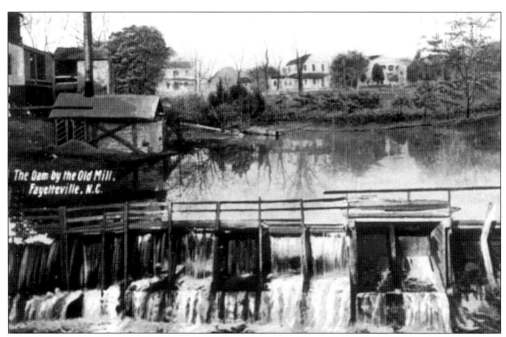

The Old Dam and Mill. The village of Cross Creek began at the site of the mill on Cross Creek just south of the present-day Green Street bridge over the creek. This 1907 view looks west from across the dam. This same view first appeared in a painting from 1816. (Courtesy of Special Collections Library, Duke University.)

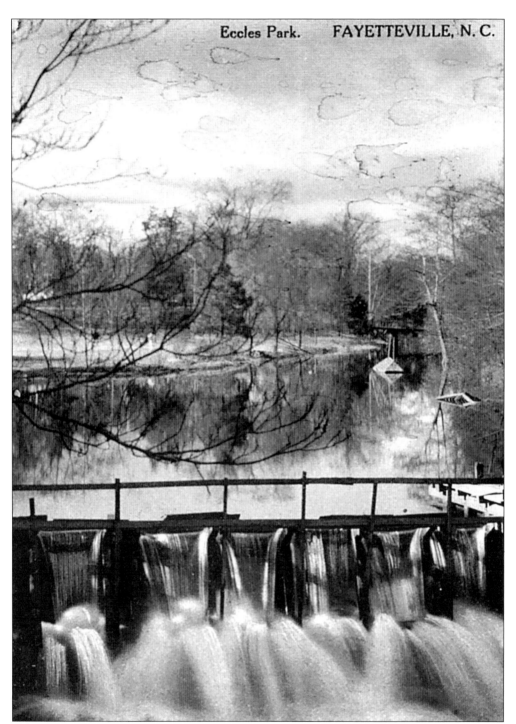

Eccles Park. FAYETTEVILLE, N.C.

FLOWING WATER. Cross Creek was a meandering stream before millwright John Newberry constructed the dam for his 1754 grist mill in what is now the heart of downtown Fayetteville. For nearly 250 years, it has flowed strongly over a series of dams at the same spot. This hand-colored card of about 1908 shows the water at full force. (Courtesy of Roy Parker Jr.)

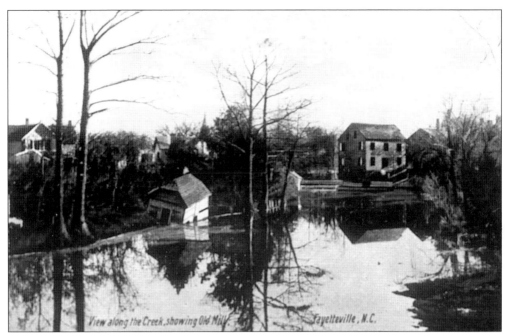

View along the Creek, showing Old Mill. — Fayetteville, N.C.

LATER SCENE. In the early 20th century, the boathouse on Eccles Pond seems to have collapsed into the pond. This view looks east toward the mill and the backyards of houses on Green Street. (Courtesy of Special Collections Library, Duke University.)

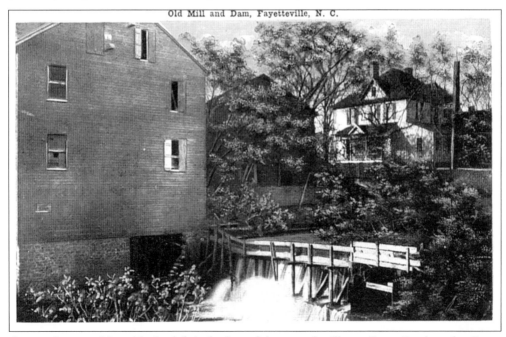

Old Mill and Dam, Fayetteville, N. C.

GREEN STREET MILL. To the left is the last of the several mills on Cross Creek at the Green Street site, where John Newberry first established a mill in 1755. This one was owned by James McNeill, a noted politician and fire chief, mayor of Fayetteville, a founder of the North Carolina Fireman's Association. McNeill's mill closed in 1940. (Courtesy of Larry Tew.)

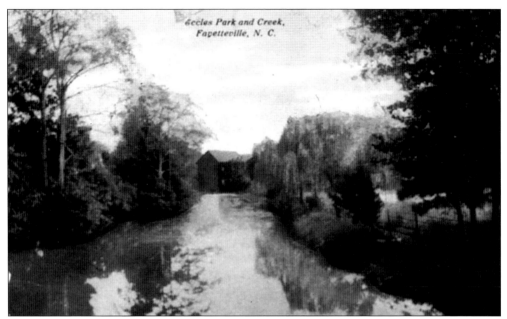

ECCLES PARK. In the 1890s, the pond behind the Green Street dam was known as Eccles Park and boasted a boathouse and rental canoes. The boating organization was known as the Cyclone Club. This view looks east along the tree-lined Cross Creek and pond with the mill in the far background. (Courtesy of Special Collections Library, Duke University.)

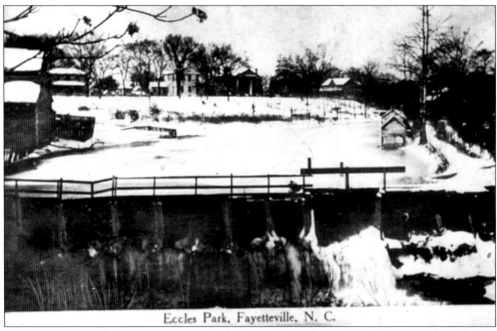

POND IN SNOW. This rare snow scene clearly shows the Eccles Pond boathouse on the right and homes on Anderson Street in the background. The pond is no more; it was filled in and is today a parking lot. (Courtesy of Special Collections Library, Duke University.)

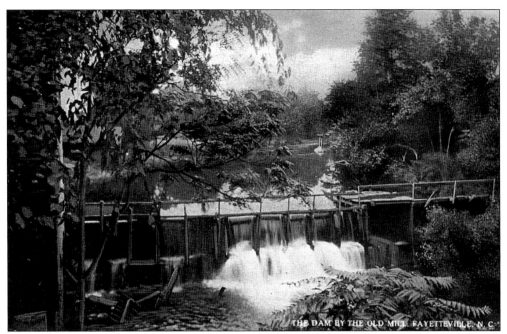

ROMANTIC SETTING. This richly tinted card of 1916 depicts the old Green Street mill site and dam as decidedly romantic, a sylvan view that stands in sharp contrast to the earlier workaday views. (Courtesy of Roy Parker Jr.)

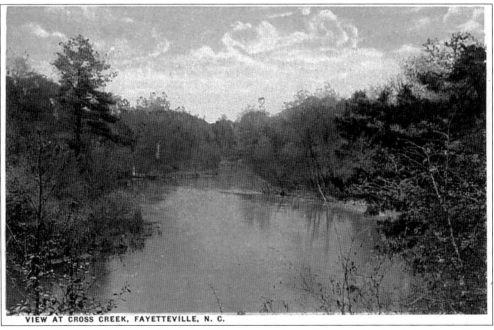

AUTUMN FOLIAGE. In color, this early 20th-century view of the pond behind the Green Street dam is a festival of autumn colors. The late growth along the southern (right) edge of the water obscures the mill, but the cupola of the Market House is shown dimly in the middle background. (Courtesy of Roy Parker Jr.)

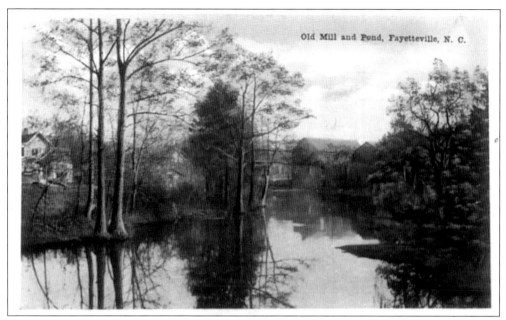

LOOKING EAST. This view looks east along the millpond formed by the dam at the Green Street bridge, with the old mill in the background. The last mill on the site remained into the 1930s. (Courtesy of Special Collections Library, Duke University.)

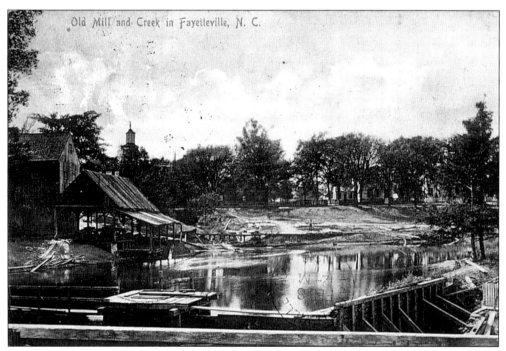

THE MILLPOND. The millpond formed behind the mill at Green Street flowed across the east side of Anderson Street in the background of this 1910 view. The town's first Baptist church, built in 1837, is on the left, and the Presbyterian manse is in the middle. (Courtesy of Eddie Durako.)

Three

PUBLIC BUILDINGS
AND BUSINESS

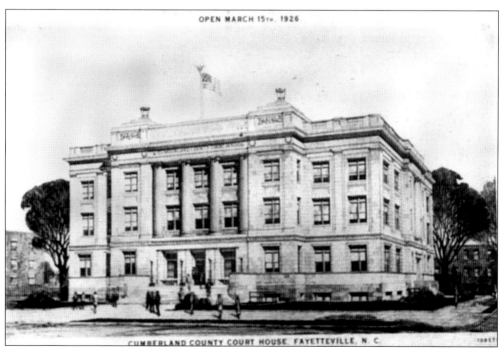

SIXTH COURTHOUSE. Cumberland County's sixth courthouse opened in 1926 on Gillespie Street where mule barns and corrals once surrounded the fifth courthouse. The imposing stone-faced structure is seen in this view in the form of the architect's rendering. (Courtesy of Special Collections Library, Duke University.)

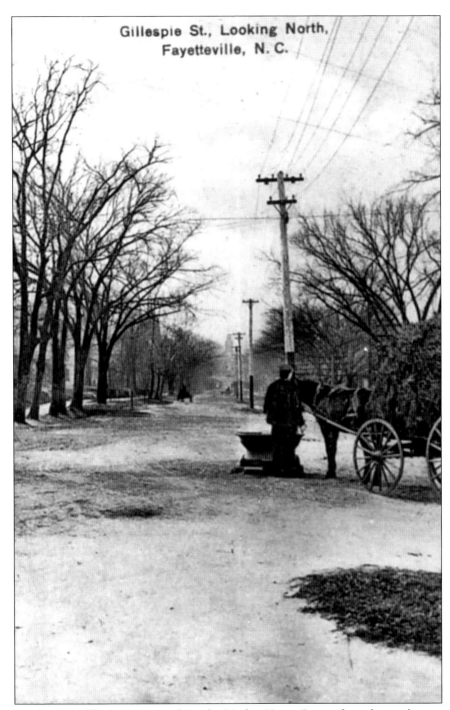

Gillespie St., Looking North, Fayetteville, N. C.

GILLESPIE STREET. The street approaching the Market House Square from the south was named for John Gillespie of Duplin County, one of the commissioners who laid out the streets of newly-named Fayetteville in 1783. This early 20th-century view looks north toward the Market House. (Courtesy of Special Collections Library, Duke University.)

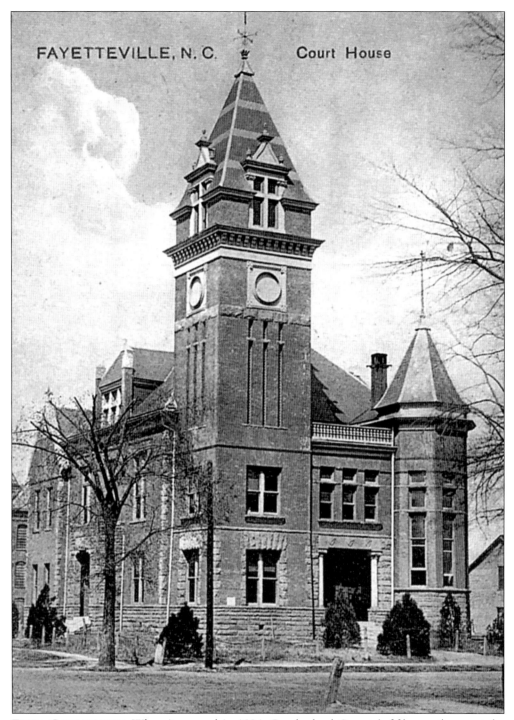

FAYETTEVILLE, N.C. Court House

FIFTH COURTHOUSE. When it opened in 1894, Cumberland County's fifth courthouse at the corner of Gillespie and Russell Streets was surrounded by the barns and corrals of Bevill's mule empire. A two-story jail in the same popular Victorian style was located behind the courthouse. (Courtesy of John and Jerry Gimish.)

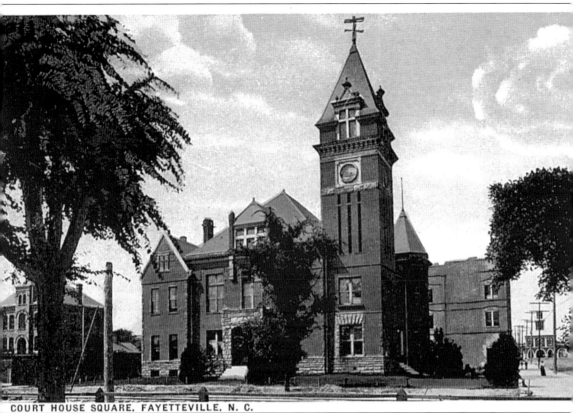

COURT HOUSE SQUARE, FAYETTEVILLE, N. C.

JAIL HOUSE. This view of the 1894 Cumberland County courthouse from Russell Street shows the jail house building in the left background. The last hangings carried out by county officials took place in the open interior well of the jailhouse. (Courtesy of Ken Suggs.)

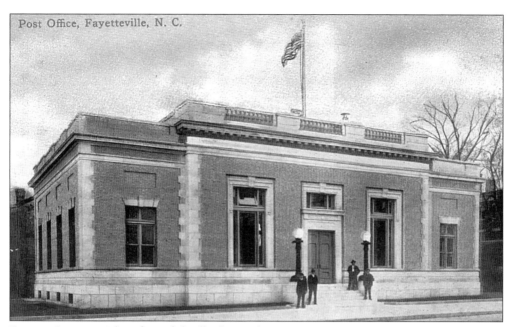

Post Office, Fayetteville, N. C.

POST OFFICE. The first federally-financed structure in Fayetteville since the U.S. Arsenal before the Civil War was the Beaux Arts-style U.S. Post Office building, which opened in 1910 on Hay Street at the corner of Maxwell Street. It served until 1961, when it became a public library, and then in 1986 was remodeled as a public arts center. (Courtesy of Ken Suggs.)

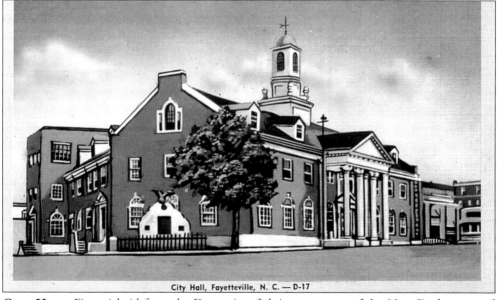

City Hall, Fayetteville, N. C. — D-17

CITY HALL. Financial aid from the Depression-fighting programs of the New Deal supported construction of the Fayetteville City Hall, which opened in 1940 on Green Street at the corner of Bow Street. President Franklin D. Roosevelt paid a brief visit to the building in 1941 while he was on an inspection trip to Fort Bragg. Today, it is a children's museum. (Courtesy of Larry Tew.)

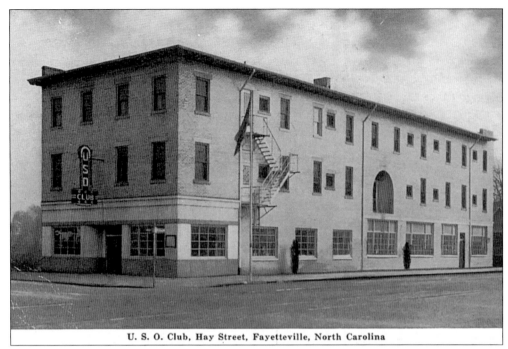

U. S. O. Club, Hay Street, Fayetteville, North Carolina

USO CENTER. During World War II, the recreational services organization known as USO operated 11 different centers in Cumberland County to serve soldiers at Fort Bragg. This was the women's center at 439 Hay Street in 1944. It served the Women's Army Corps, nurses, and civilian employees from the big Army post. (Courtesy of Roy Parker Jr.)

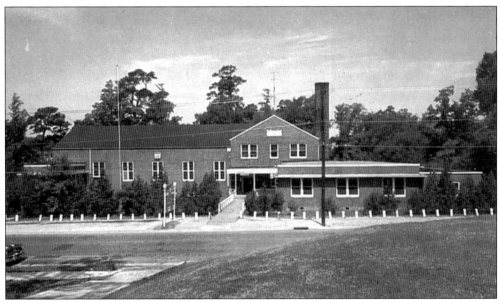

RAY AVENUE. The most elaborate of the USO centers of World War II was this USO Community Service Club on Ray Avenue, which offered a full array of recreational opportunities and a favorite dance floor. It remains today as a city-owned community center. (Courtesy of Ken Suggs.)

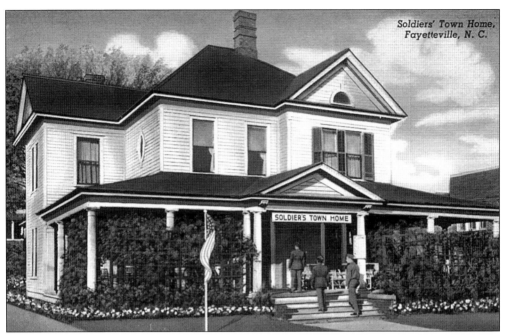

SOLDIERS' TOWN HOME. The former parsonage of Hay Street Methodist Church next to the church on Old Street was used during World War II as a recreational haven for the thousands of soldiers who served at Fort Bragg. (Courtesy of Larry Tew.)

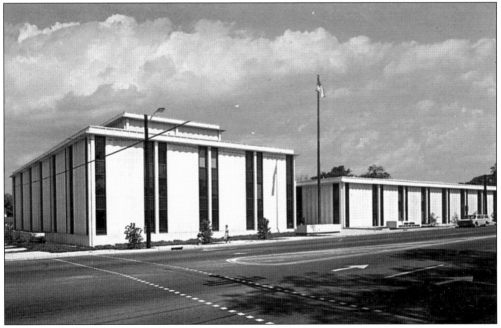

FEDERAL BUILDING. Green Street's old residential character disappeared in the 1960s when nearly two blocks were cleared for the new U.S. Post Office and Federal Building, which opened in 1965. By congressional act, the building is now officially named for a longtime mayor, the late J.L. Dawkins. (Courtesy of Larry Tew.)

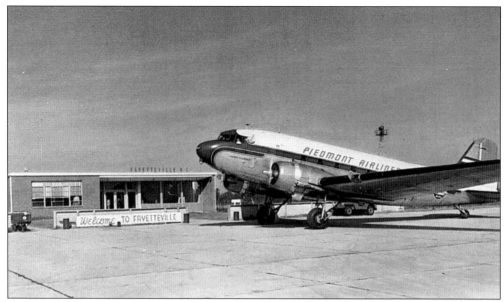

AVIATION PROGRESS. Piedmont Airlines began passenger service on a dirt runway at the new Fayetteville Municipal Airport in 1949. The airline, based in Winston-Salem, popularized air travel in the reliable DC-3 aircraft, shown in this card. By the 1970s, the airline and the airport were prospering, with new facilities and runways. Passengers were greeted by the flamboyant "Welcome to Fayetteville" sign across the front of the terminal. (Courtesy of Larry Tew.)

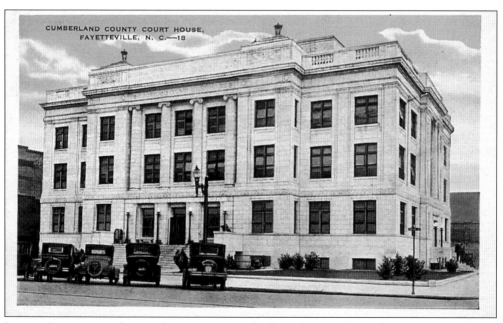

LEGAL COCKPIT. As the population grew and the face of crime changed, the sixth courthouse became the location of Cumberland County's legal battles for a half-century. The county jail was on the top floor of the structure. The main courtroom was done in rich wood paneling, complete with the Ten Commandments on a frieze surrounding the judge's bench. (Courtesy of John and Jerry Gimish.)

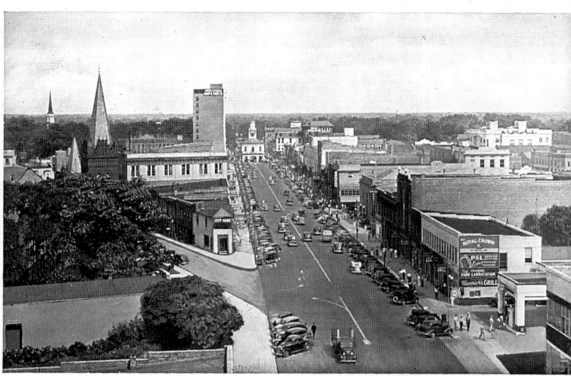

Business Section, Looking East on Hay Street, Fayetteville, North Carolina

PUBLIC SKYLINE. This 1930s view looking east along Hay Street was taken from the roof of the Prince Charles Hotel and shows the skyline of public buildings in downtown Fayetteville. Visible are the Market House, the sixth courthouse, and spires of downtown churches. (Courtesy of John and Jerry Gimish.)

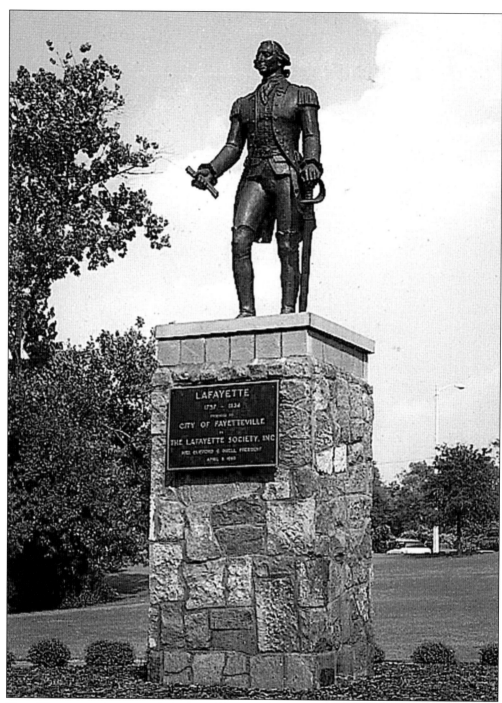

CITY NAMESAKE. A comparatively new addition to the public landscape of downtown Fayetteville is the statue of the Marquis de Lafayette, the city's namesake. Fayetteville was the first place in North America named for the French hero of the War of Independence. In 1783, the then 25-year-old village of Cross Creek was renamed in his honor. His statue stands on Cross Creek Park between Ann and Green Streets.

Four

HOUSES OF WORSHIP

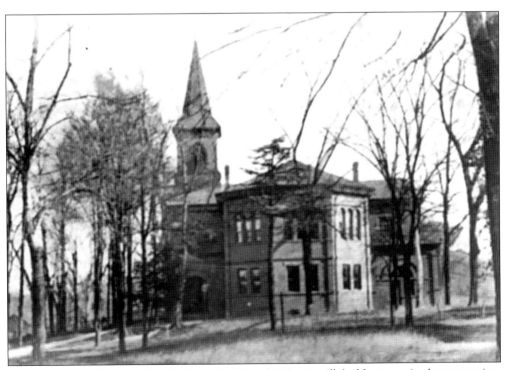

PRESBYTERIAN CHURCH. First Presbyterian Church is Fayetteville's oldest organized congregation, first meeting in 1800. This late 19th-century view of the church on Ann Street is the much-remodeled structure dating from 1832, built after the original 1817 structure was destroyed in the Great Fire of 1831. Further remodeling included a new steeple in 1922. (Courtesy of Special Collections Library, Duke University.)

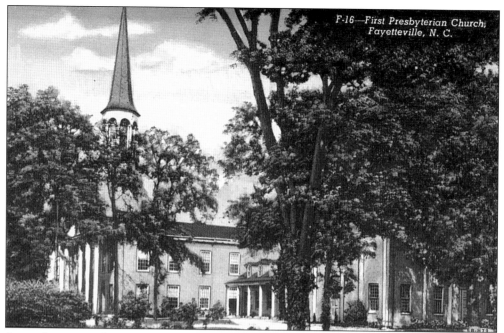

ANN STREET. This is a modern view of First Presbyterian Church on Ann Street, emphasizing the 1920s steeple designed by Hobart B. Upjohn. In the colonial village of Cross Creek, the site of the church was referred to in deeds as "Society Hill." (Courtesy of Eddie Durako.)

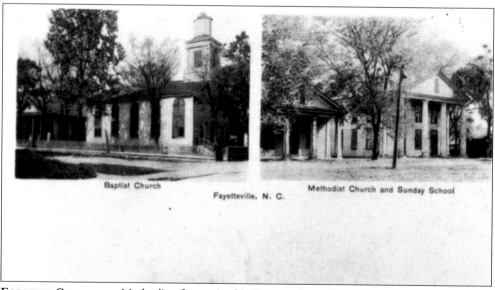

EARLIEST CHURCHES. Methodists first arrived in Fayetteville with the free black preacher Henry Evans in the 1780s. The church buildings in this early 20th-century view were erected beginning in 1837 at the corner of Old Street and Ray Avenue. The first Baptist church in Fayetteville was organized in 1837 and the church building depicted in this early 20th-century view was constructed that year at the corner of Old and Anderson Streets. (Courtesy of Special Collections Library, Duke University.)

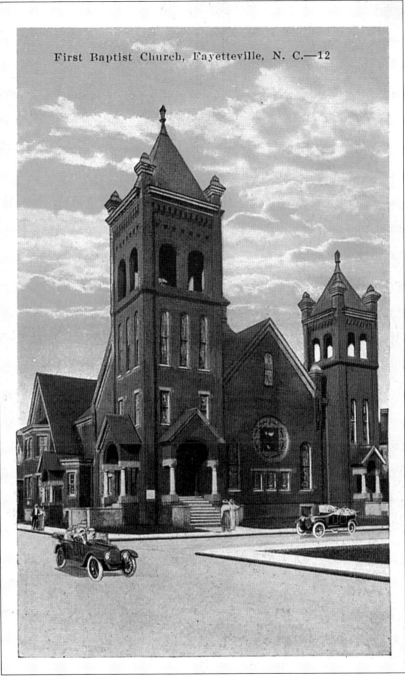

First Baptist Church, Fayetteville, N. C.—12

FIRST BAPTIST. Built in 1910 on the site of the original 1837 church building at the corner of Old Street and Anderson Street, First Baptist's new building competed with Hay Street United Methodist as a rich example of the highly-popular Gothic Revival style of church architecture. Since the 1840s, Baptists have been the most numerous denomination in Fayetteville. (Courtesy of John and Jerry Gimish.)

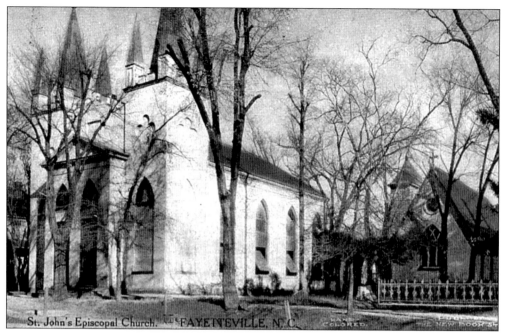

St. John's Episcopal Church. FAYETTEVILLE, N. C.

ST. JOHN'S. The first of six Episcopal churches in Fayetteville is St. John's on Green Street. The present-day structure was built in 1832 on the ruins of an 1817 structure, which had been destroyed in the Great Fire just a year before. This card from 1910 also depicts the chapel on the right. (Courtesy of Clarence Winstead.)

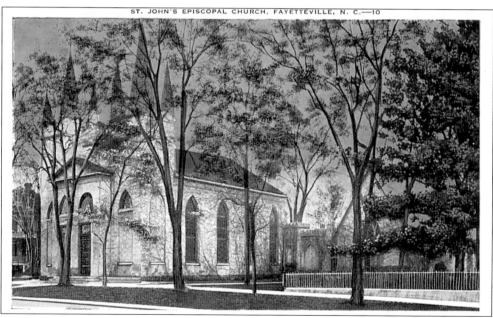

ST. JOHN'S EPISCOPAL CHURCH, FAYETTEVILLE, N. C.—10

IN LEAF. This somewhat later color view of St. John's is interesting because the bare limbs of the earlier winter scene are now covered with a smattering of springtime foliage, and the angle brings the big magnolia on the right into nearly full view. The tree was actually in the front yard of the adjoining Kyle House, now owned by the church. (Courtesy of Roy Parker Jr.)

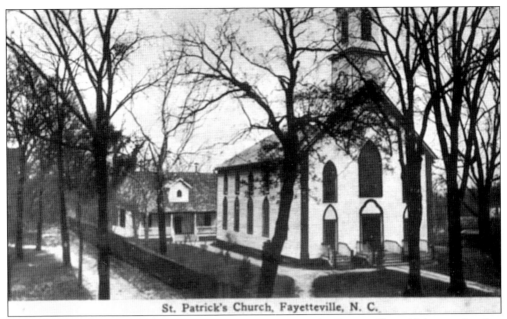

St. Patrick's Church, Fayetteville, N. C.

ROMAN CATHOLIC. The Roman Catholic congregation in Fayetteville, which was the first in North Carolina and known as Saint Patrick's, was consecrated in 1829. This handsome wooden church was built in 1832 on Bow Street at the Person Street intersection and served the Roman Catholic community until 1936. (Courtesy of Special Collections Library, Duke University.)

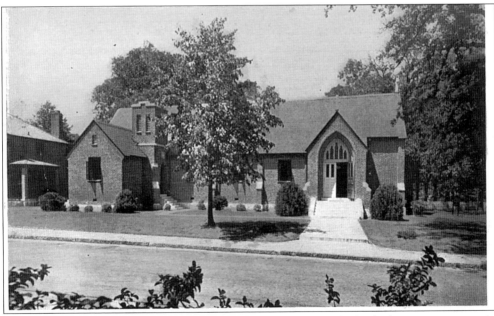

SAINT PATRICK'S. The Roman Catholic parish of Saint Patrick's built this new sanctuary in 1936 on Arsenal Street in Haymount. It replaced original church building of 1832. When a new sanctuary was built on Village Drive in the 1960s, this became a Maronite Catholic church. (Courtesy of Larry Tew.)

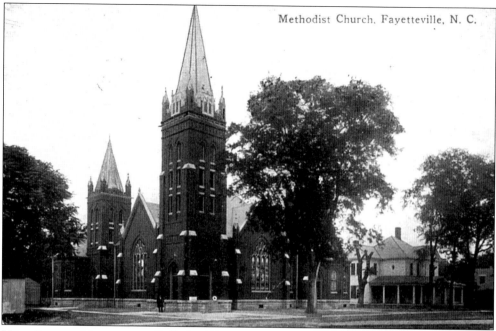

Methodist Church, Fayetteville, N. C.

HAY STREET METHODIST. Built in 1908 on the site of an original 1835 church building, the Hay Street United Methodist Church just off Hay on Old Street at the corner of Ray Avenue is an elegant example of Gothic Revival style and includes a unique semi-circular sanctuary. This card from 1912 clearly shows the parsonage on the right, now a parking lot. (Courtesy of Larry Tew.)

HAYMOUNT RISE. Among Fayetteville churches, none was more elegantly made or styled than Haymount Presbyterian Church, built in the 1870s for an African-American congregation on the rise of Hay Street to Haymount. Its soaring steeple is seen on the right in this early 20th century view looking east. Built by self-made architect Dallas Perry, the structure was immortalized in a painting by Elliot Daingerfield. It burned in the 1980s. (Courtesy of Special Collections Library, Duke University.)

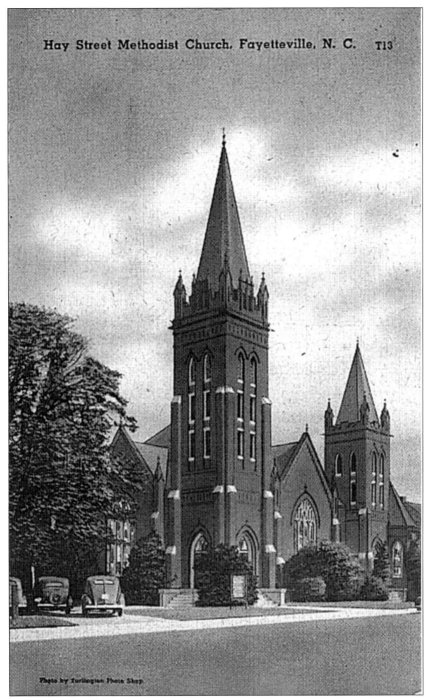

Hay Street Methodist Church, Fayetteville, N. C. T13

Photo by Turlington Photo Shop

TOWERING VIEW. This handsome color card with the soaring angle on the steeple of Hay Street Methodist is the work of Army Sgt. H.A. Turlington, whose Turlington Photo Shop was responsible for scores of postcard views of Fayetteville and Fort Bragg in the 1930s. (Courtesy of Roy Parker Jr.)

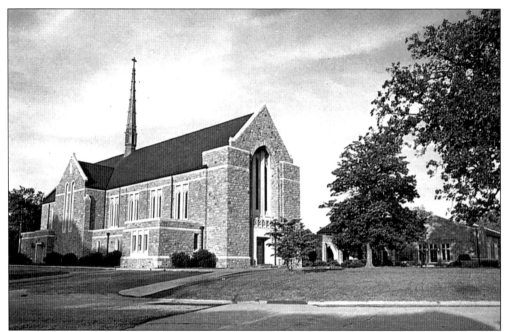

HAYMOUNT METHODIST. Cumberland County's rapid population growth in the 1960s resulted in many new suburban churches. Haymount Methodist Church, organized in 1945, opened this soaring brick and stone sanctuary building on Bragg Boulevard in 1964. (Courtesy of Larry Tew.)

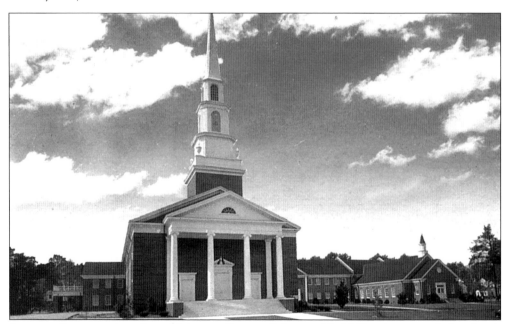

SNYDER BAPTIST. A major addition to Fayetteville's post–World War II array of churches is Snyder Memorial Baptist Church on Westmont Avenue off Bragg Boulevard. This modern view of the church building emphasizes the fact that the congregation is often regarded as the largest in Cumberland County.

Five

EDUCATION

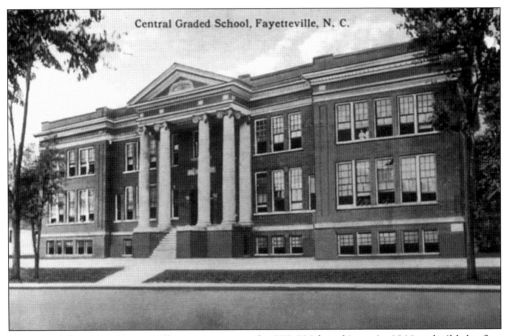

CENTRAL SCHOOL. Fayetteville voters approved a $50,000 bond issue in 1910 to build the first brick structures dedicated to public schooling for white children. Central School on Maiden Lane and Burgess Street served for more than 40 years. (Courtesy of Special Collections Library, Duke University.)

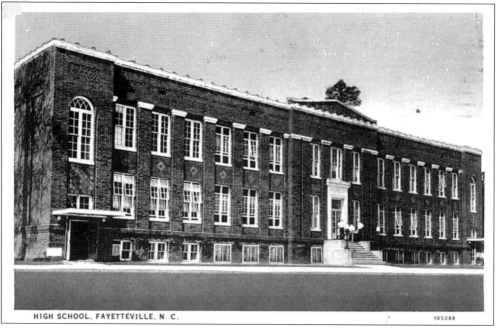

HIGH SCHOOL, FAYETTEVILLE, N. C. 105298

HIGH SCHOOL. The first modern public high school in Fayetteville was Alexander Graham School, built in 1921 for white students and named for the first superintendent of local white public schools after the Civil War. (Courtesy of Clarence Winstead.)

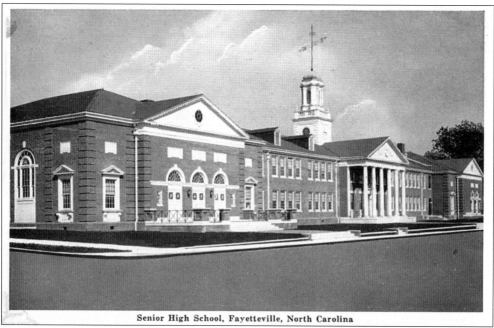

Senior High School, Fayetteville, North Carolina

FAYETTEVILLE HIGH. Built with help from the Works Progress Administration of the New Deal, this new Fayetteville High School for white students opened in 1940 on the west side of Robeson Street between Hay and McGilvary Streets. It replaced the Graham school and served until the 1960s. (Courtesy of Larry Tew.)

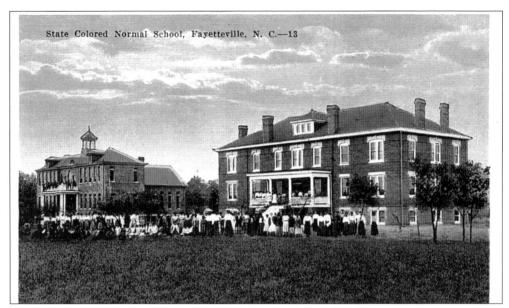

State Colored Normal School, Fayetteville, N. C.—13

NORMAL SCHOOL. Today's Fayetteville State University began in 1865 as a school for children of free slaves. In this view of about 1914, the school had been the State Colored Normal School for nearly 40 years. Its campus on Murchison Road boasted two state-financed buildings, Aycock Hall (1908) on the left and Vance (1910) on the right. The entire student body gathered for this picture. When school children raised money for a statue to Gov. Charles B. Aycock on the Capitol grounds in Raleigh, African-American children of Cumberland gave more than any county in the state. (Courtesy of Larry Tew.)

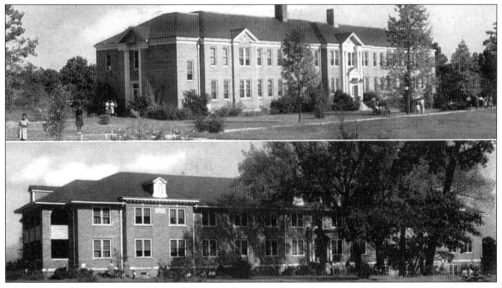

TEACHERS COLLEGE. In 1939, the Normal School had become Fayetteville State Teachers College. These two dormitories were part of an extensive building program when the institution performed a major role training African-American teachers in North Carolina during the decades of racial segregation in the public schools. Both still exist today. (Courtesy of Roy Parker Jr.)

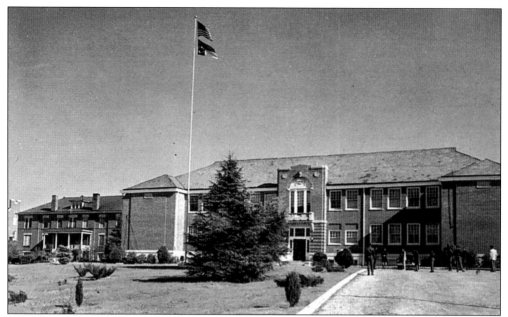

ADMINISTRATION BUILDING. The E.E. Smith Administration Building at FSTC was named for Dr. E.E. Smith, president of the institution off an on from 1883 to 1933. Old Vance Hall is seen at the left. (Courtesy of Roy Parker Jr.)

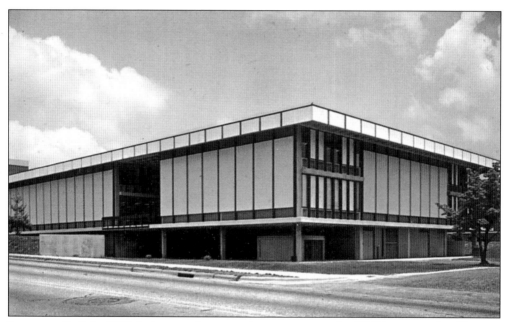

LIBRARY. Built in 1967 during a major expansion program on the FSTC campus, the Chesnutt Library was named for Charles W. Chesnutt (1858–1933), who went from serving as principal of the early school to becoming the country's first nationally-recognized African-American novelist and short story writer. A newer building, also named for Chesnutt, went up in the 1990s. (Courtesy of Eddie Durako.)

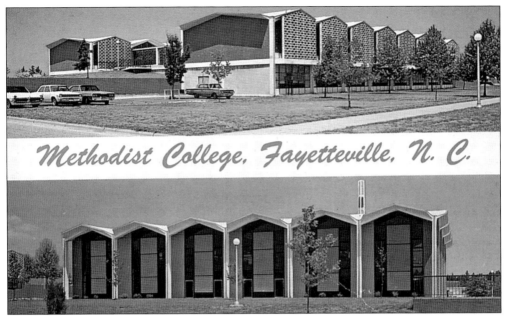

METHODIST COLLEGE. Opened in 1960 as a two-year institution, Methodist College on Ramsey Street today offers a four-year curriculum. This early view highlights the unique architecture of the classroom building (top) and Geraldine Tyson Memorial Library, notably the masonry sunscreens, which were designed by Atlanta architects Stevens and Wilkinson.

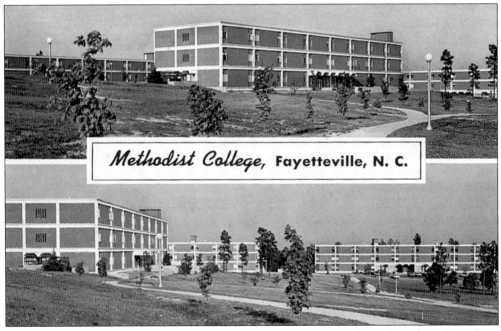

METHODIST DORMITORIES. Planned from its inception as a campus for students from throughout southeastern North Carolina, Methodist College included dormitories for men and women. More than half the student body continue to live in these structures and others added in the 1990s. (Courtesy of Larry Tew.)

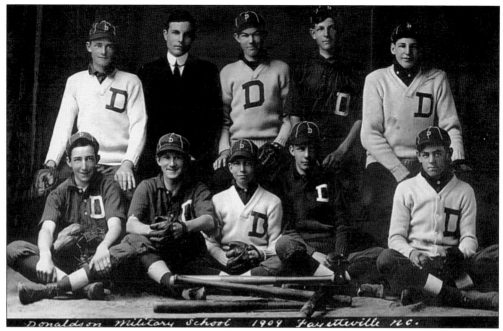

DONALDSON MILITARY. Among the earliest postcard views of Fayetteville educational institutions is a series of scenes from Donaldson Military School, taken soon after 1911. Donaldson was by then located on Raeford Road. This its baseball team. (Courtesy of Clarence Winstead.)

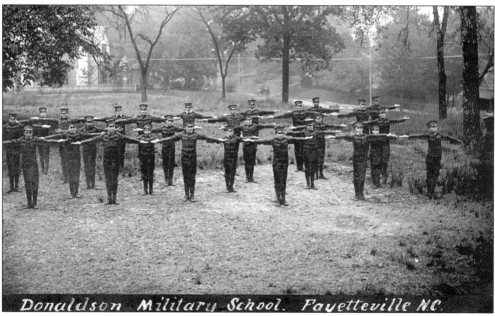

DONALDSON DRILL. The military school adopted the name of an antebellum academy on Haymount and used the old building of the Donaldson Academy for several years. Many of the turn-of-the-century town's leading families sent their male children to Donaldson. (Courtesy of Clarence Winstead.)

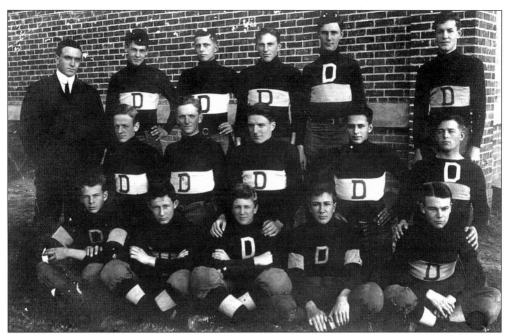

IN JERSEYS. The Donaldson football team members are shown dressed in their official jersey. The sports programs of the school attracted boys from throughout the upper Cape Fear area. (Courtesy of Clarence Winstead.)

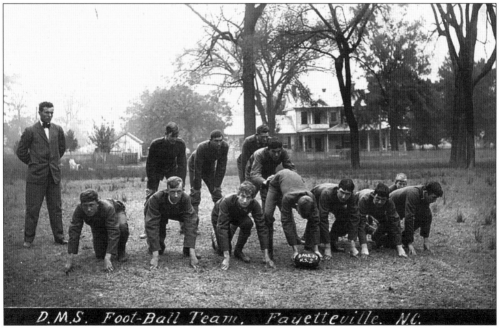

D.M.S. Foot-Ball Team, Fayetteville, N.C.

FOOTBALL. The boys of Donaldson Military School were playing football in the first years of the 20th century. This view looks north across Raeford Road, which bordered the school's grounds on a high plateau between Raeford Road and Winterlochen Road. Notice the score on the ball. (Courtesy of Clarence Winstead.)

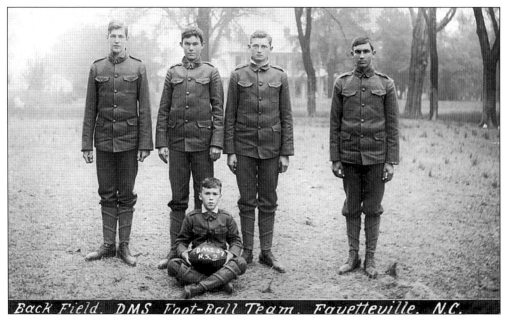

LATEST UNIFORM. The football in this picture appears to be the same as the one depicted in the image of the team lineup (at the bottom of page 65). This uniform was patterned on the latest U.S. Army design. Many Donaldson graduates served in World War I between 1917 and 1918. The school closed in 1920. (Courtesy of Clarence Winstead.)

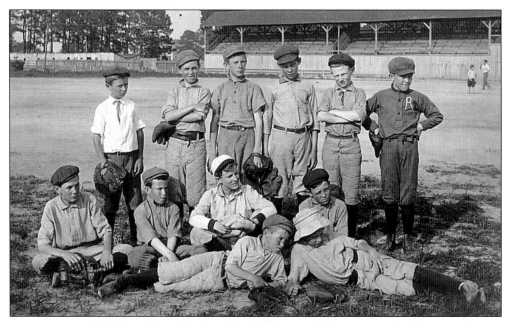

FAIRGROUNDS. This Donaldson Academy baseball team, which seems to be the junior league team, poses on the field at the Cumberland County fairgrounds with the grandstand in the background. The fairgrounds were south of Blounts Creek on the west side of Gillespie Street. Baseball history was made on the same field in 1914, when George Herman "Babe" Ruth hit his first home run in an exhibition game. (Courtesy of Clarence Winstead.)

ORANGE STREET SCHOOL. Built in 1915 as the first brick school structure for African American children in Fayetteville, the Orange Street School served for classrooms until after World War II. It has been preserved as a historic landmark and houses as museum of the early African-American educational life of the city. (Courtesy of Roy Parker Jr.)

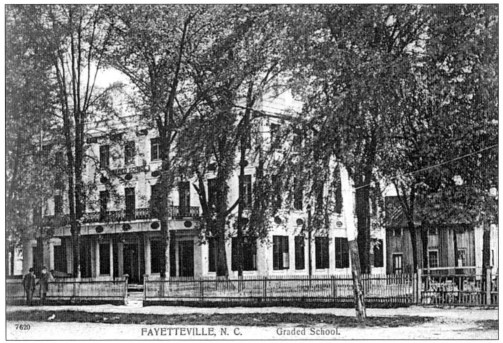

FAYETTEVILLE, N. C. Graded School.

HAY STREET SCHOOL. Built just before the Civil War as a high school for females, this building on the south side of the 300 block of Hay Street was later a military academy, a hotel, and the a public school, as it was in this 1908 view. It was demolished in the 1920s. (Courtesy of Roy Parker Jr.)

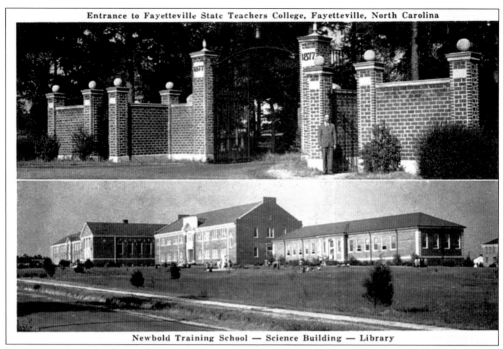

Entrance to Fayetteville State Teachers College, Fayetteville, North Carolina

Newbold Training School — Science Building — Library

AFTER WORLD WAR II. An interesting feature of this FSTC card from after World War II is the view in the upper portion depicting the school's new entrance off Murchison Road with Pres. J. W. Seabrook posed on the right. (Courtesy of Larry Tew.)

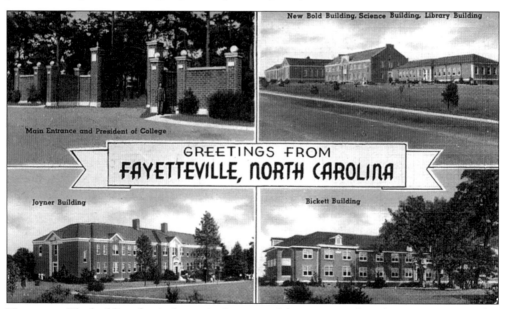

New Bold Building, Science Building, Library Building

Main Entrance and President of College

GREETINGS FROM
FAYETTEVILLE, NORTH CAROLINA

Joyner Building

Bickett Building

NEWBOLD. The building that is shown in the upper right was erected on the FSTC campus after World War II for teacher training classes. It was named Newbold for the state's longtime director of African-American education. The building included a classroom wing that was also part of the local school system, and was called Newbold Training School. At one time, the address of the entire campus was Newbold Station. (Courtesy of Clarence Winstead.)

Six

HEALTHCARE

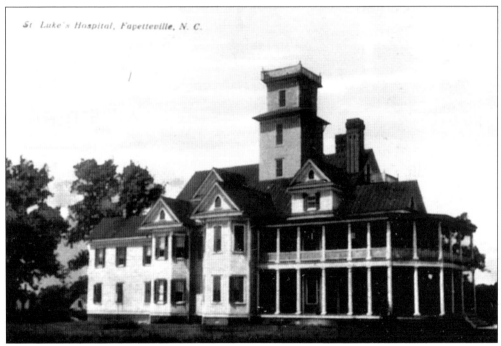

ST. LUKE'S. A striking example of hospital design just prior to the modern era was St. Luke's Hospital, built in 1904 by Dr. John Henry Marsh. It was in Haymount, in the block bounded by Morganton Road, Broadfoot and Highland Streets, and Arsenal Avenue. It lasted only a few years. Elements salvaged from the building, mainly columns and dormers, can still be seen in several old houses on Broadfoot and Arsenal. (Courtesy of Special Collections Library, Duke University.)

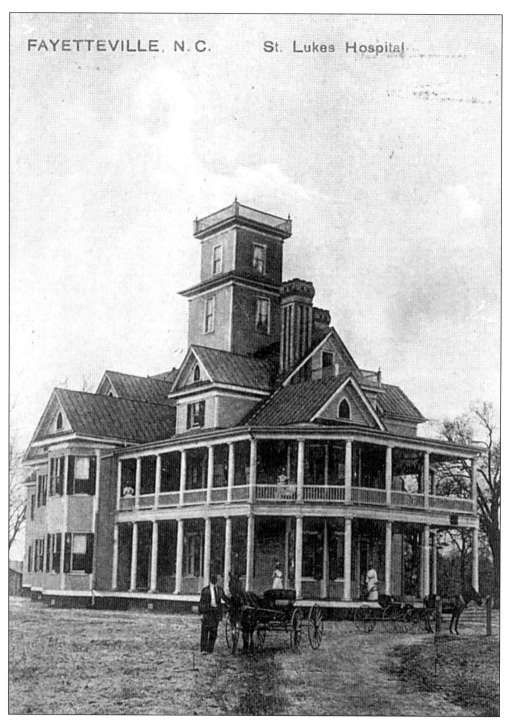

FAYETTEVILLE, N.C. St. Lukes Hospital

TOWERING CARE. The tall tower of St. Luke's was the latest thing for patients with respiratory ailments, getting them as far up into clean air as possible. Notice the nurses on the veranda. Dr. Marsh started a nurse training program from the beginning of his practice. (Courtesy of Clarence Winstead.)

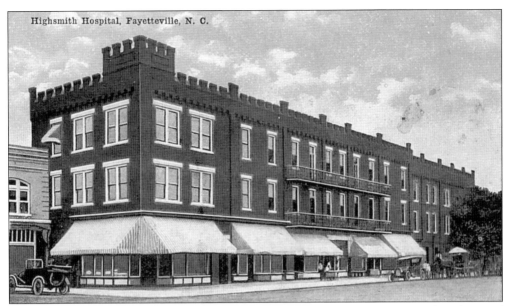

Highsmith Hospital, Fayetteville, N. C.

HIGHSMITH. Fayetteville's first up-to-date hospital was built in 1906 after fire destroyed an 1896 "sanitarium" on the site. It took up most of the west side of the first block of Green Street from the Market Square to Old Street. Dr. Jacob Franklin Highsmith was its owner. (Courtesy of Roy Parker Jr.)

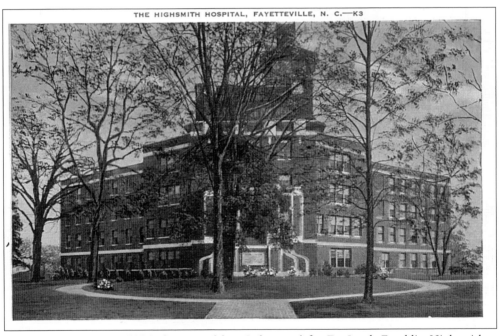

THE HIGHSMITH HOSPITAL, FAYETTEVILLE, N. C.—K3

NEW HIGHSMITH. In 1926, the second hospital named for Dr. Jacob Franklin Highsmith, a fully modern facility with a nearby building for the school of nursing, opened on Haymount at the corner of Hay and Bradford Streets. The 100-bed hospital would serve for more than 50 years. Today, it is a facility of the Cumberland County mental health agency. (Courtesy of Eddie Durako.)

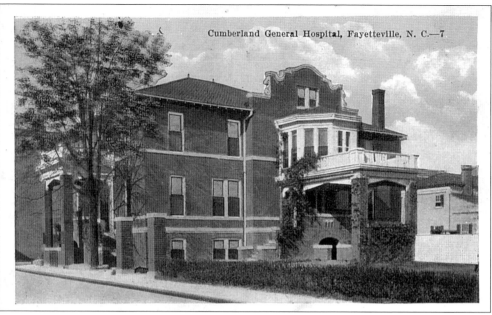

Cumberland General Hospital, Fayetteville, N. C.—7

CUMBERLAND GENERAL. Cumberland General Hospital, built in 1912, was a venture of Dr. Seavy Highsmith, who was a nephew of Dr. Jacob Highsmith, and Dr. Thomas M. West. The building, destroyed by fire in 1977, stood on the north side of Old Street next to the First Baptist Church. Highsmith was associated with the hospital until his death in 1942. It was later converted to a rooming house known as Ivy Inn. (Courtesy of Larry Tew.)

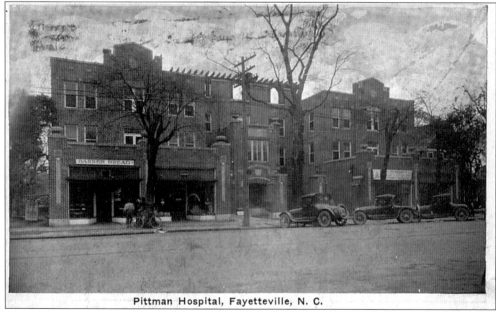

Pittman Hospital, Fayetteville, N. C.

PITTMAN HOSPITAL. Built in 1919 on the south side of the 400 block of Hay Street, Pittman Hospital was financed and operated by Dr. Raymond Pittman. It was later converted to a department store. When the store was razed for a new city hall in the 1990s, the old facade of the hospital was uncovered. This is a 1928 view. (Courtesy of Manfred and Sonia Rothstein.)

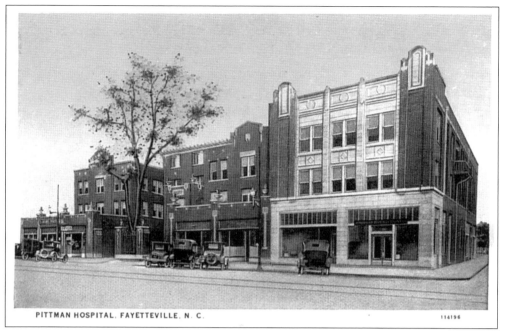

PITTMAN HOSPITAL. This later view of Pittman shows that a wing has been added to the west and the building was the centerpiece of the south side of the 400 block of Hay Street. (Courtesy of Ken Suggs.)

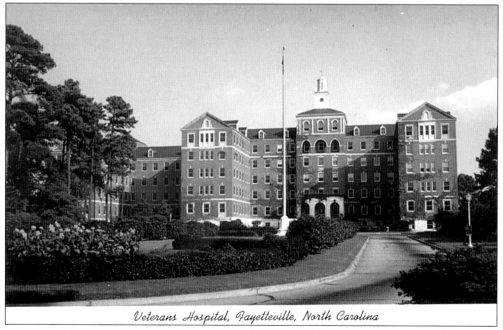

Veterans Hospital, Fayetteville, North Carolina

VETERANS' HOSPITAL. Over the bitter opposition of Raleigh, Fayetteville was picked as site for the North Carolina Veterans Administration Hospital, which opened in late 1940 on Ramsey Street. A unique feature of the design of the facility is the central tower, which replicates the shape and cupola of the Market House. (Courtesy of Eddie Durako.)

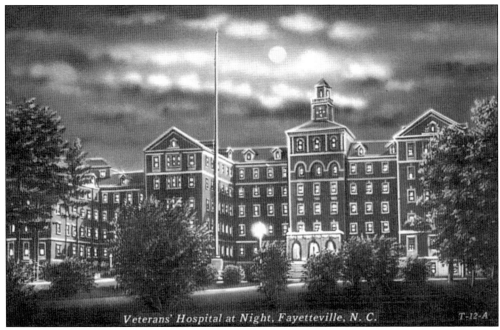

MOONLIGHT VIEW. The Veterans' Hospital, now known as the Veterans Medical Center, has been enlarged several times. This view has a caption describing a $1.5 million addition.

CAPE FEAR VALLEY. In 1954, the year Pittman Hospital closed, county-owned Cape Fear Valley Hospital opened on Owen Drive on the western outskirts of Fayetteville. Its site was donated by the Sandrock family and was across from a shopping mall known as Bordeaux, which had been named for a scuppernong grape winery that operated there in the early 20th century. (Courtesy of Larry Tew.)

Seven

THE FLOOD OF 1908

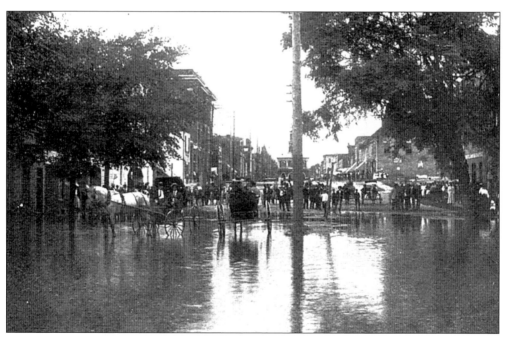

THE BIG FLOOD. When the Cape Fear River flooded in August of 1908, photography flourished, and many Fayetteville scenes were first captured on film. The most photographed of all 1908 Fayetteville flood scenes was the view looking west on Person Street toward the Market House, with the water just short of the intersection of Person and Bow Streets on the right. (Courtesy of Clarence Winstead.)

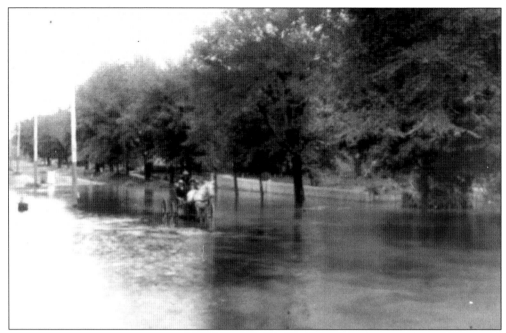

GREEN STREET. The river swirled within a block of the Market House on Person, and Cross Creek became a torrent on other streets. This scene shows Cross Creek out of its banks flooding the Eccles Bridge on Green Street. (Courtesy of Special Collections Library, Duke University.)

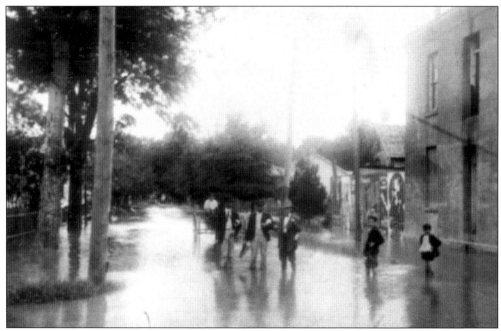

CROWDS GATHERED. As the 1908 flood waters began to recede, Fayettevilleans flooded the streets to get a look at the phenomenon, and buggy owners hitched up their horses to test the soggy roadways. (Courtesy of Special Collections Library, Duke University.)

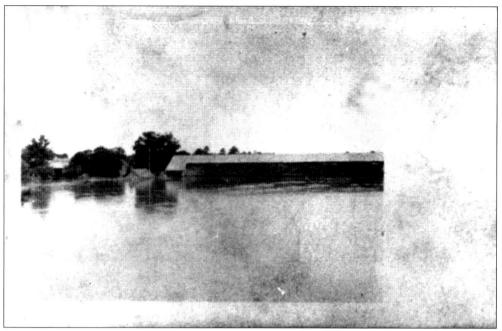

RIVER BRIDGE. The first photos of the wooden covered bridge over the Cape Fear were taken to show how the river nearly flooded it. This bridge was built after the original 1819 bridge was destroyed by retreating Confederate soldiers in 1865. It was an exact copy of the original. (Courtesy of Special Collections Library, Duke University.)

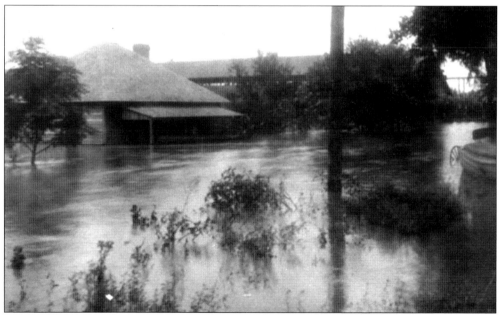

TRUSS STRUCTURE. This closer look at the 1908 flood waters around the west end of the Cape Fear River bridge illustrates the lattice-like truss work of its design. The form was patented in 1819 by Ithiel Town, who was builder of the original 1819 bridge, known as the Clarendon Bridge. (Courtesy of Special Collections Library, Duke University.)

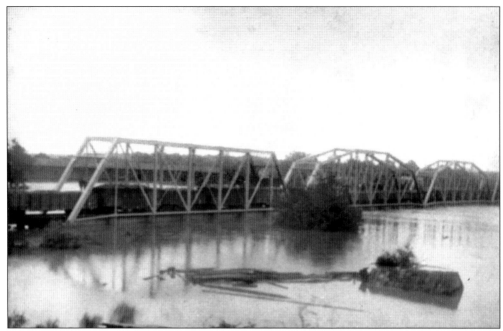

RAILROAD BRIDGE. The steel truss railroad bridge over the Cape Fear just south of the wooden bridge was threatened by the 1908 flood waters because its piers were so new. Loaded coal cars were parked on the bridge in an effort to stabilize it. (Courtesy of Special Collections Library, Duke University.)

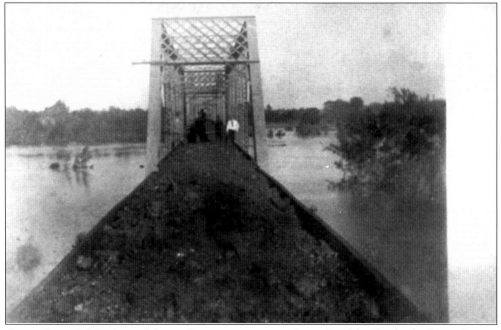

COAL CARS. This view of the coal car operation on the railroad bridge looks from the east side of the Cape Fear River toward Fayetteville. (Courtesy of Special Collections Library, Duke University.)

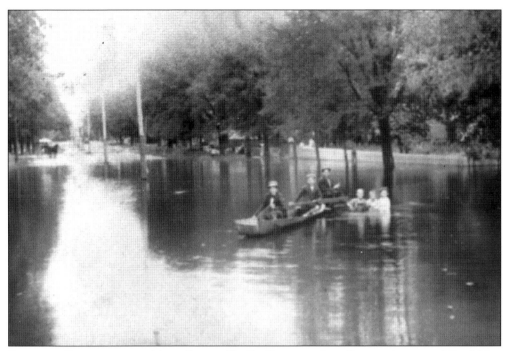

BOATING OPPORTUNITY. Many Fayetteville families owned small punts, boats used for fishing on creeks. However, they were used for other purposes when the 1908 flood waters covered the streets. (Courtesy of Special Collections Library, Duke University.)

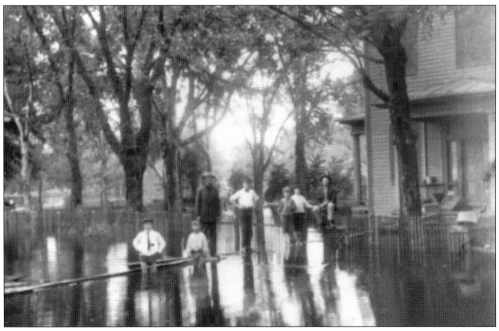

WET FEET. Young boys and men in bow ties and fedora hats tried out the muddy Cape Fear water as it inched up into the middle of Fayetteville. (Courtesy of Special Collections Library, Duke University.)

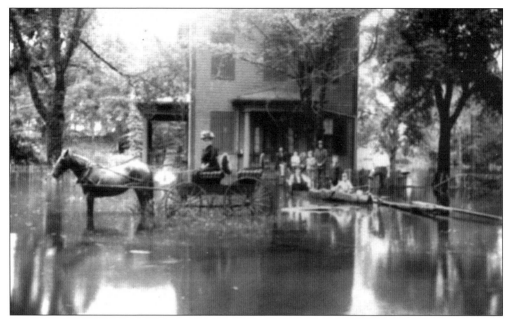

TRANSPORTATION. The photography from the 1908 flood provides vivid visual information about the modes of early 20th century transportation in Fayetteville, as well as about what fashionable ladies wore when driving their four-wheelers. (Courtesy of Special Collections Library, Duke University.)

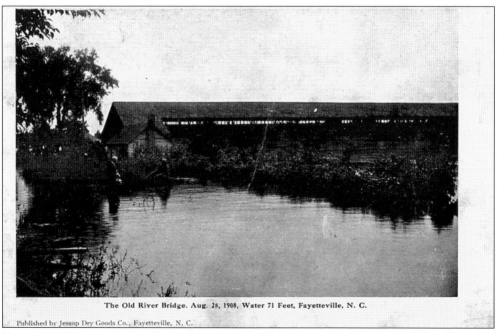

The Old River Bridge. Aug. 28, 1908, Water 71 Feet, Fayetteville, N. C.

Published by Jessup Dry Goods Co., Fayetteville, N. C.

SOUVENIR. This rare card with the date of the flood is among the best views of the Clarendon Bridge, showing the open upper sides and the trusswork copied from the original bridge designed by Ethiel Town in 1819. The card was published by Jessup Dry Goods Co., an early promoter of local postcards.

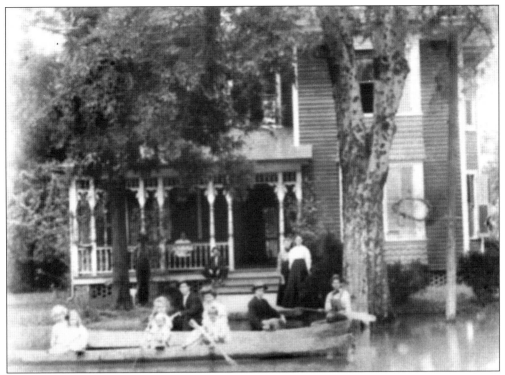

BOATING TIME. The whole family seems to have taken to this punt, while an admiring crowd looks on from the porch. Another flood view, this one also provides good information about clothing fashions of men and women. (Courtesy of Special Collections Library, Duke University.)

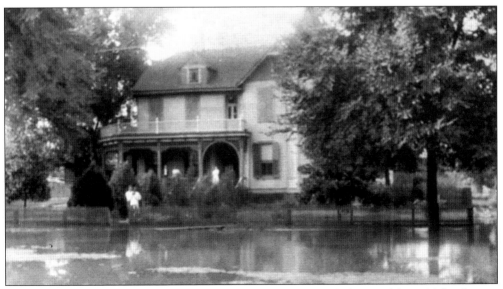

FLOODED RESIDENCES. Homes on lower Person Street suffered the brunt of the 1908 flood water. The street was lined with residences almost to the river waters. (Courtesy of Special Collections Library, Duke University.)

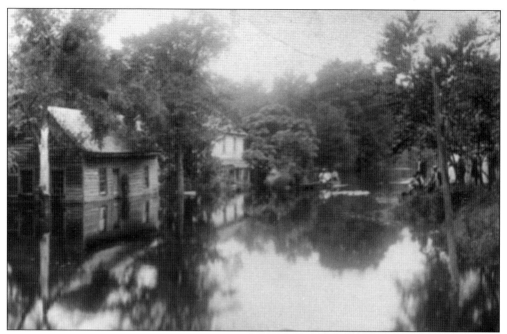

HIGH WATER. Cross Creek flooded its banks almost into the heart of Fayetteville. Normally a shallow stream, it became an impressive waterway in this view. (Courtesy of Special Collections Library, Duke University.)

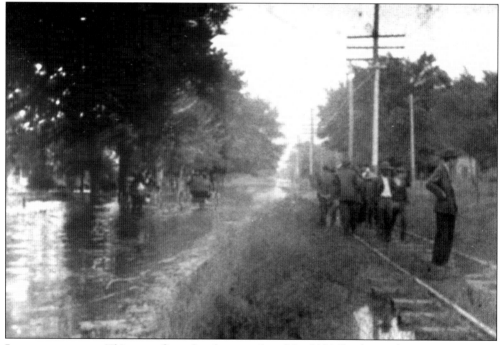

INFRASTRUCTURE. This scene from the photography of the 1908 flood provides interesting visual information about the construction of railroads and the ubiquitous electric power lines of the early 20th century. (Courtesy of Special Collections Library, Duke University.)

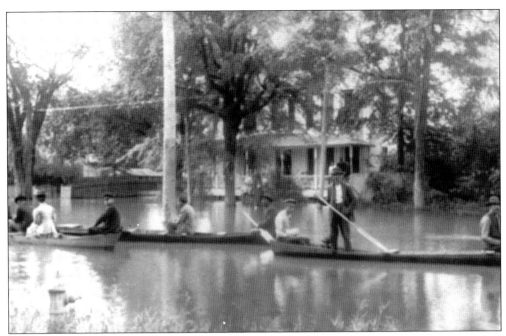

ROAD TRAFFIC. A veritable traffic jam of punts crowding this view and provides an array of visual information about the shape of the homemade boats, as well as of the clothing fashions of the boaters. (Courtesy of Special Collections Library, Duke University.)

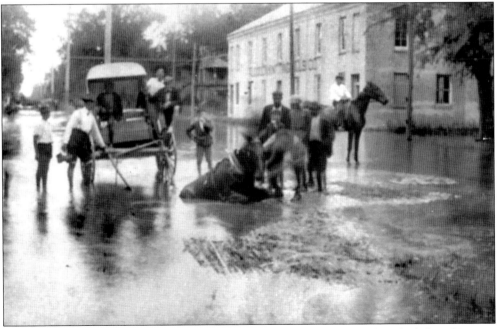

SINKING HORSE. No photograph from the Flood of 1908 was more cherished than this great view of the buggy horse's predicament. Good visual information about men's and boy's clothing, and a good view of the L. Cook Knitting Mills Company building on Person Street are also provided. (Courtesy of Special Collections Library, Duke University.)

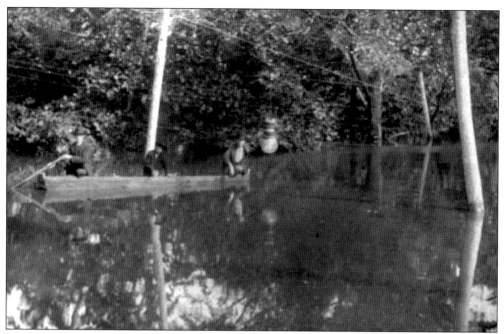

PUNTING TIME. When they grew up, these youngsters would recall their feats of punting in the floodwaters that covered much of the low-lying areas of Fayetteville for several days. (Courtesy of Special Collections Library, Duke University.)

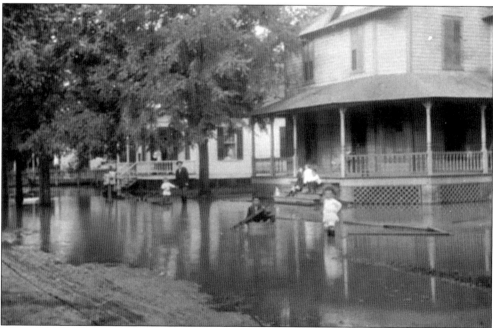

SUNDAY BEST. These children seem to be in their Sunday best, minus shoes, as they stand in the receding floodwaters on lower Person Street. Every family on the street would treasure a photograph from the days of the high water. (Courtesy of Special Collections Library, Duke University.)

Eight

HOTELS AND LODGING

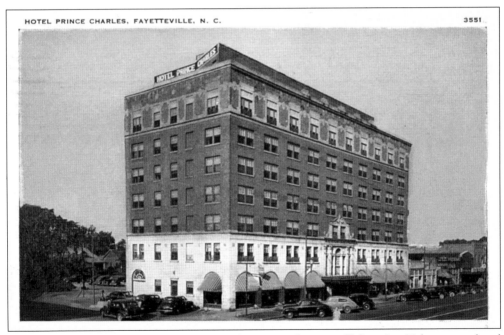

HOTEL PRINCE CHARLES, FAYETTEVILLE, N. C. 3551

PRINCE CHARLES. A public contest chose the name of Fayetteville's major 20th-century hotel and The Prince Charles opened in 1926 on the north side of Hay Street's 400 block. This 1943 view provides a glimpse in the left background of the residential character of Maiden Lane in those days. (Courtesy of Larry Tew.)

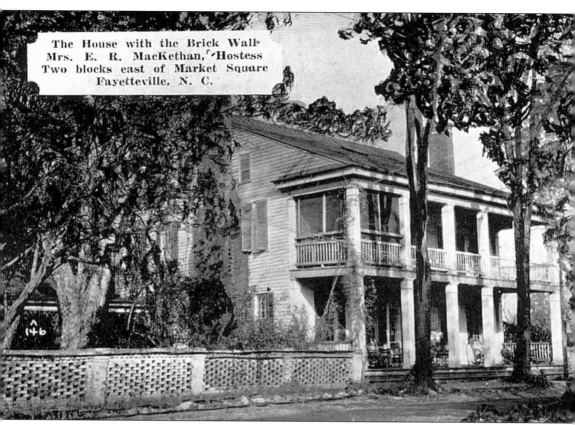

The House with the Brick Wall
Mrs. E. R. MacKethan, Hostess
Two blocks east of Market Square
Fayetteville, N. C.

COOL SPRING TAVERN. Considered Fayetteville's oldest structure, portions of the house shown above, which is located on Cool Spring Street, date to the late 18th century when it was a tavern and hostelry for visiting members of the North Carolina General Assembly. These members met in Fayetteville before Raleigh was named the permanent state capital. By the 1930s, it was a guest house, referred to as "the house with the brick walls." The owner, Mrs. E.R. McKethan, listed herself as hostess. (Courtesy of Clarence Winstead.)

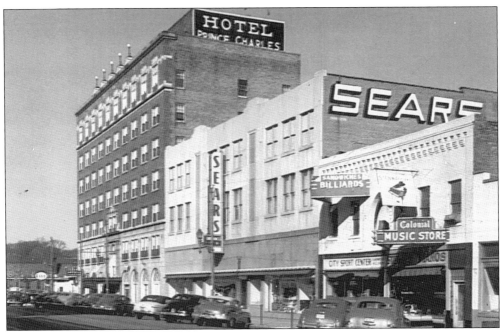

MODERN HOSTELRY. Built in 1925 as a civic project, the Prince Charles Hotel was Fayetteville's most modern hostelry for 30 years. It and the adjoining Sears store were mainstays of Hay Street during the 1930s and 1940s. (Courtesy of Larry Tew.)

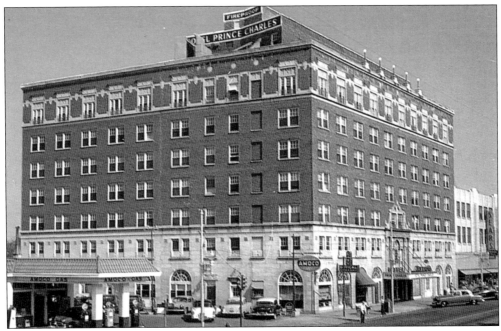

HOTEL IN THE 1950s The expanded Prince Charles was a busy place in World War II, with such guests as movie star Mickey Rooney, who was in town to entertain troops at Fort Bragg. After the war, it continued as a popular stop for motorists. This view is from the 1950s. (Courtesy of Eddie Durako.)

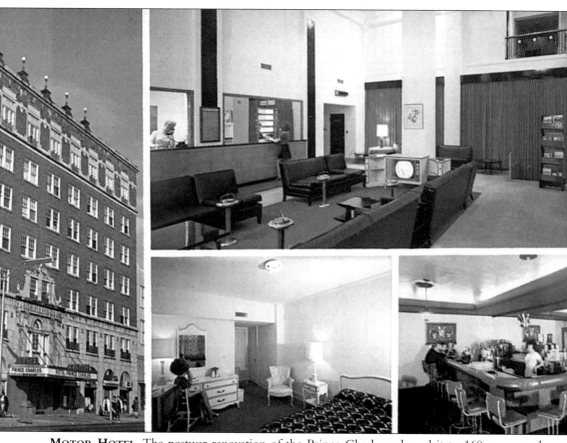

MOTOR HOTEL. The postwar renovation of the Prince Charles enlarged it to 160 rooms and changed its emphasis from the railroad trade to the automobile trade by billing itself as the Prince Charles Motor Hotel. A single cost $7, and the hotel boasted "Fayetteville's nicest tap room," according to this card. But by the 1960s, it was abandoned. It came to new life in the 1990s as a hotel of the Radisson chain. (Courtesy of Larry Tew.)

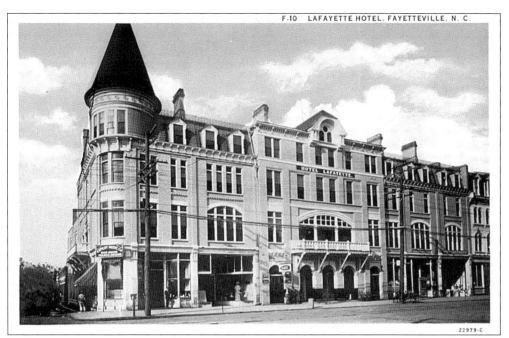

LAFAYETTE. The up-to-date Lafayette Hotel open in 1885 on the southwest corner of Hay and Donaldson Streets, just across Donaldson from the site of famous antebellum hostelry where the Marquis de Lafayette attended a ball during his 1825 overnight in the village named in his honor. That hotel burned in the Great Fire of 1831. (Courtesy of Roy Parker Jr.)

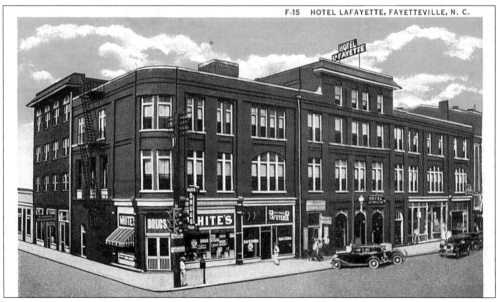

MISSING TOWER. The Lafayette lost its tower in a fire and was extensively renovated afterward. Its first floor continued as a popular place for businesses, including White's Drug Store, which appears in this 1930s view. Long abandoned, the old building was destroyed by a spectacular nighttime fire in the mid-1990s. A new office building, with a modernistic tower echoing the original, was completed in 2000. (Courtesy of Ken Suggs.)

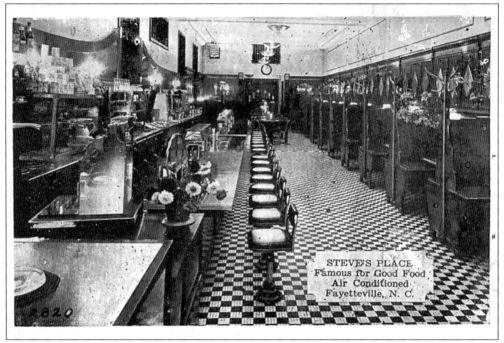

GREEK RESTAURANT. Families from Greece who arrived in Fayetteville in the early 20th century owned many of the community's eating places. In 1940, Steve's Place was the forerunner of today's Haymount Grill. (Courtesy of John and Jerry Gimish.)

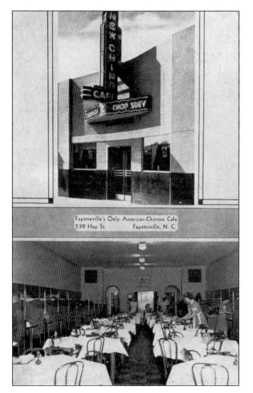

NEW CHINA. Among the many new eating places spawned by World War II was the New China Cafe, located in a handsome art deco style building at 539 Hay Street. It opened in 1942, operated by Kim Geo and A. T. Wong. It was for many years "Fayetteville's only American-Chinese Cafe." It moved to Raeford Road by 1962.(Courtesy of Roy Parker Jr.)

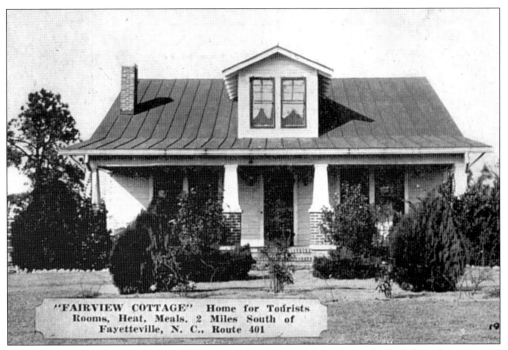

TRAVEL HOME. Motorists along U.S. 301 in the 1930s and 1940s could find few places to stop outside urban areas. But the Fairview Cottage south of Fayetteville was an early entry into what would now be called the "bed and breakfast."

HAYMOUNT GUESTS. The Martel Guest House at 812 Hay Street on Haymount was opened by 1939. It was operated by Mrs. M.E Dunlap. She advertised ample parking and a nearby garages.(Courtesy of Larry Tew.)

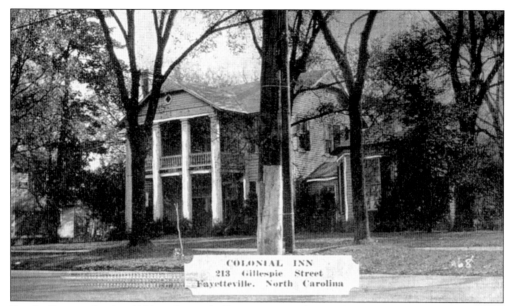

FAN'S PLACE. In the 1930s a house built in 1808 at the southeast corner of intersection of Gillespie and Russell Streets became the Colonial Inn, a tourist home presided over by "Miss Fan" Williams, who was born in the house. Her hospitality was known far and wide, and the southern food prepared by the greatly admired Mary Sanders was famous among travelers who regularly came to Fayetteville. (Courtesy of Manfred and Sonia Rothstein.)

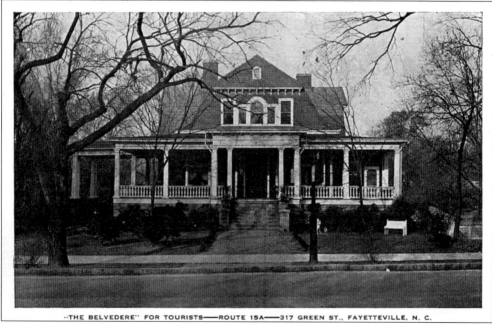

THE BELVEDERE. A former residence in the most desirable residential row on Green Street north of the Market House, the Belvidere offered tourists a precursor of the "bed and breakfast" type of accommodation that has become poplar worldwide. It was located at 317 Green. The street was on the busy national highway of the 1930s, which was numbered 15A.

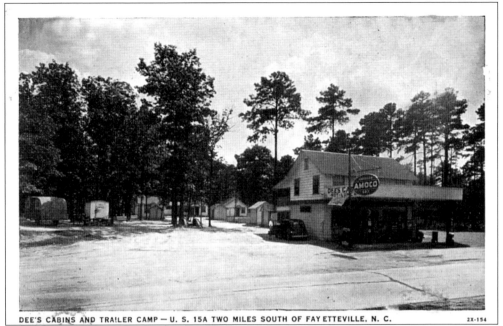

DEE'S CABINS AND TRAILER CAMP — U. S. 15A TWO MILES SOUTH OF FAYETTEVILLE, N. C. 2X-154

EARLY CABINS. The 1930s boom in highway motoring brought north–south traffic through the heart of Fayetteville on U.S. Highway 15A, later U.S. 301. Dee's Cabins and Trailer Camp was among the early places catering to the traffic. It was located south of the town on a segment of highway that today is lined with such businesses. (Courtesy of Manfred and Sonia Rothstein.)

THOMPSON'S COTTAGE COURT
(UNITED MOTOR COURTS)

POPULAR STOP. Thompson's Cottage Court was the most elaborate of the early establishments on U.S. 15A south of Fayetteville. Joe L. Thompson's tourist cabins boasted "shower baths in every room, and plenty of hot and cold water at all times." (Courtesy of Larry Tew.)

93

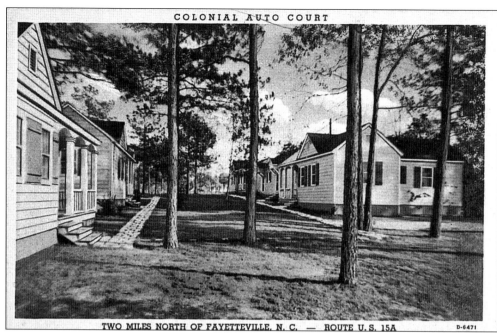

COLONIAL AUTO COURT

TWO MILES NORTH OF FAYETTEVILLE, N. C. — ROUTE U.S. 15A

D-6471

COLONIAL AUTO COURT. Two miles north of Fayetteville on 15A, the Colonial Auto Court Inn was a popular example of the cottage model of roadside accommodations. It offered electric fans in each cottage. Mr. and Mrs C.W. Ulrich were listed as proprietors.

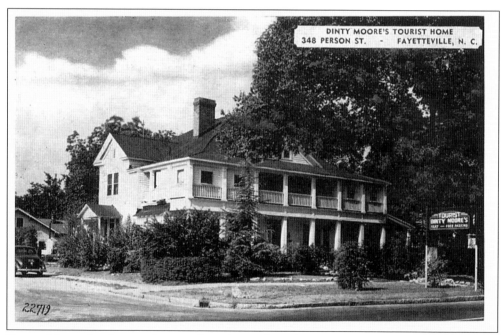

DINTY MOORE'S TOURIST HOME
348 PERSON ST. - FAYETTEVILLE, N. C.

DINTY MOORE'S. Among the most imposing early 20th-century tourist homes in Fayetteville was Dinty Moore's, located at 348 Person Street. It advertised that it was "located three blocks north of the old slave market," referring to the Market House. It offered "connecting showers" and "new inner spring mattresses" and operated for more than 30 years. This is a 1943 view.

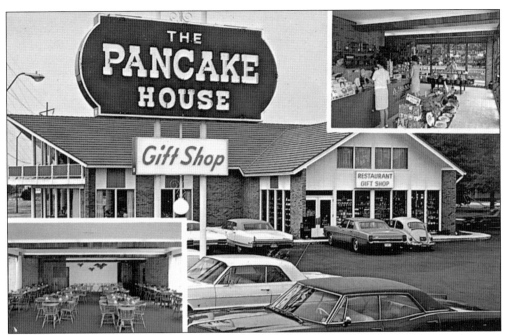

PANCAKE HOUSE. Adjoining the Ambassador, the Pancake House was by the 1970s a well-known eating place wedded to a gift shop that featured Indian crafts, North Carolina pottery, handmade jewelry, woodcraft, soap, and candles. (Courtesy of Larry Tew.)

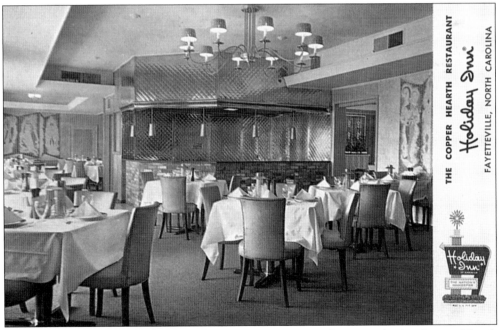

COPPER HEARTH. Like many other eating places linked to chain motels, the Copper Hearth Restaurant was the attraction at the 1970s Holiday Inn on the Eastern Boulevard corridor of U.S. 301. The open hearth grill featured a full line of steaks prepared while you watched. (Courtesy of Larry Tew.)

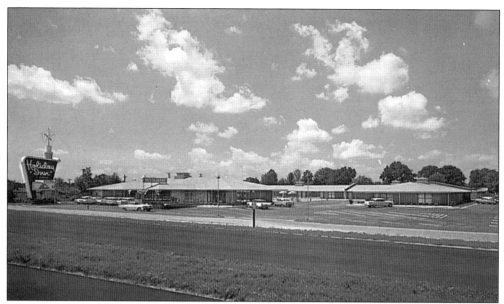

HOLIDAY INN. The big national motel chains found Fayetteville a great place to attract tourist traffic on the U.S. 301 corridor. Holiday Inn was among the largest, and when it opened on US. 301 south of the city, it boasted not only the usual amenities, but also "Teletype" connections for the busy traveling man.

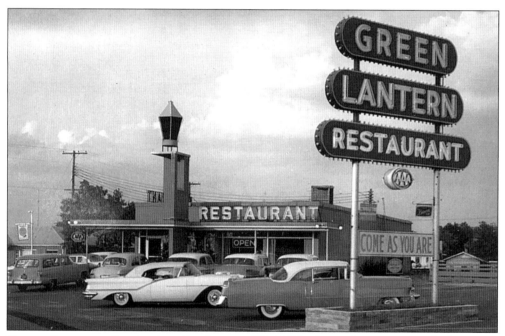

GREEN LANTERN. Just in time for the post-World War boom in motor travel, the Green Lantern Restaurant on the corridor south of Fayetteville was billed as the best on U.S. 301. It was recommended by the Duncan Hines food rating service, and by the American Automobile Association. Proprietors Clara and Harry Richmond invited travelers to "dine at the sign of the Green Lantern." (Courtesy of Larry Tew.)

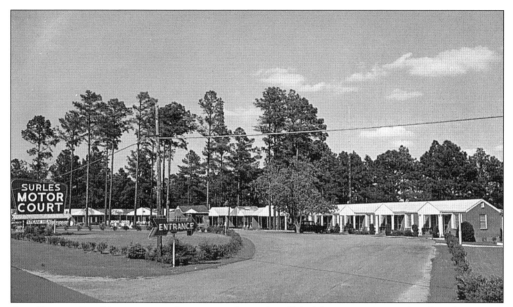

ALL BRICK. Looking more and more modern, the all-brick connecting style of Surles Motor Court was also up-to-date with a television in every room. Mary Surles was owner of the "very quiet and restful" establishment four miles south of Fayetteville on the U.S. 301 corridor. (Courtesy of Larry Tew.)

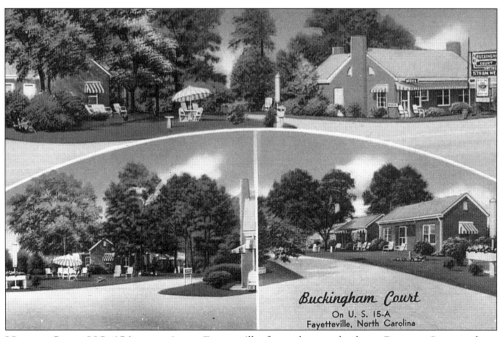

NORTH SIDE. U.S. 15A came in to Fayetteville from the north along Ramsey Street, where the U.S. Veterans Administration Hospital was opened in 1940. Buckingham Court, an array of modern brick cottages, catered to families of patients as well as travelers. Mr. and Mrs. Chalmers Smith were owner-operators of the court, which was recommended by Duncan Hines and AAA. (Courtesy of Larry Tew.)

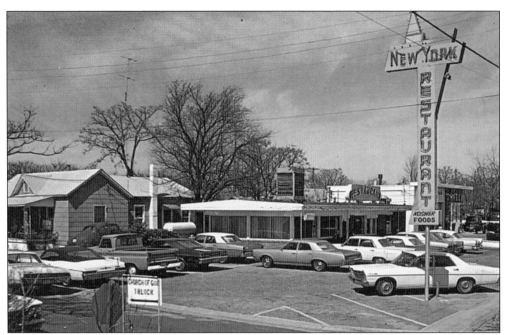

NEW YORK RESTAURANT. Gus H. Poulus, a pioneer Greek restaurateur, opened New York Restaurant on new Eastern Boulevard in the early 1950s. He catered to the busy stream of traffic between New York and Florida on U.S. 301. He offered Kosher foods as well as the southern breakfast standby of ham and eggs and grits. (Courtesy of Roy Parker Jr.)

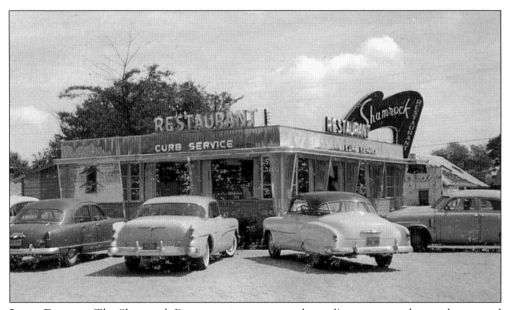

IRISH FLAVOR. The Shamrock Restaurant was among the earliest spots on the newly-opened Eastern Boulevard, the in-town segment of U.S. 301, in the 1950s. With its diner design and big neon-lit sign, it was located at the intersection with Russell Street. Despite its Irish name, the Shamrock was operated by another Greek family, that of Mike D. Manos. (Courtesy of Eddie Durako.)

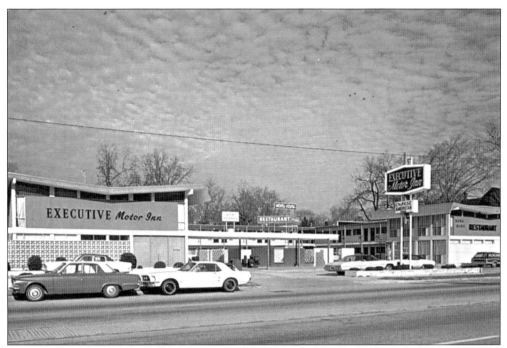

EXECUTIVE MOTOR INN. As the old downtown hotels wore out, motels came closer to the Market House center. The Executive Motor Inn opened at 333 Person Street across from the Greyhound Bus Station. It offered color TV in every room and had its own restaurant and lounge. (Courtesy of Larry Tew.)

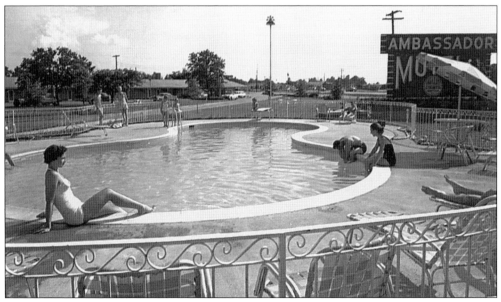

AMBASSADOR MOTEL. By the 1970, the most elaborate array of traveler accommodations along the Eastern Boulevard corridor was the Ambassador Motel. It had its own playground and swimming pool, and it was recommended by AAA. It was owned by Gene Ammons, the area's leading tourist accommodations entrepreneur. (Courtesy of Ken Suggs.)

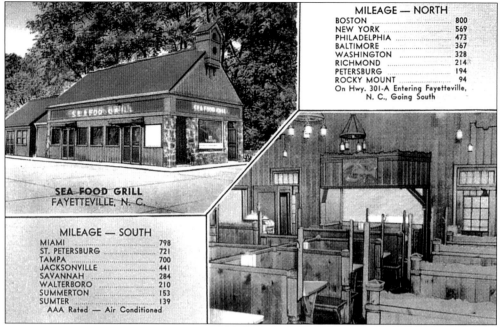

MILEAGE — NORTH	
BOSTON	800
NEW YORK	569
PHILADELPHIA	473
BALTIMORE	367
WASHINGTON	328
RICHMOND	214
PETERSBURG	194
ROCKY MOUNT	94

On Hwy. 301-A Entering Fayetteville,
N. C., Going South

SEA FOOD GRILL
FAYETTEVILLE, N. C.

MILEAGE — SOUTH	
MIAMI	798
ST. PETERSBURG	721
TAMPA	700
JACKSONVILLE	441
SAVANNAH	284
WALTERBORO	210
SUMMERTON	153
SUMTER	139

AAA Rated — Air Conditioned

SEA FOOD GRILL. The Sea Food Grill on Person Street offered a postcard with detailed mileage information about the distances from Fayetteville north to Boston or south to Miami. The chart reflected the city's claim as a mid-way point along the country's major north-south travel corridor. At the time, the route was designated 301A, and in North Carolina, it was known as the "the Tobacco Trail."

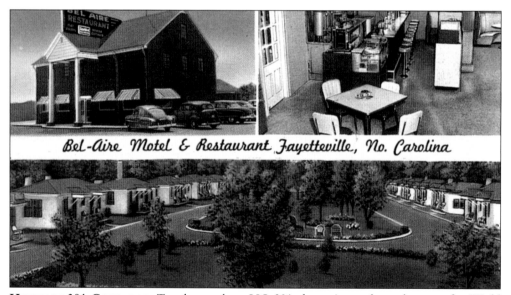

Bel-Aire Motel & Restaurant Fayetteville, No. Carolina

HIGHWAY 301 CORRIDOR. Travelers on busy U.S. 301, the main north-south route after World War II, had a variety of stopping places in Fayetteville. The Bel-Aire Restaurant and Motel three miles south of the city combined the traditional cabin-type accommodations with a restaurant that was a favorite with Fayetteville diners. The card listed mileage distances from Fayetteville— 795 miles to Miami and 803 to Boston. (Courtesy of Roy Parker Jr.)

Nine

FORT BRAGG

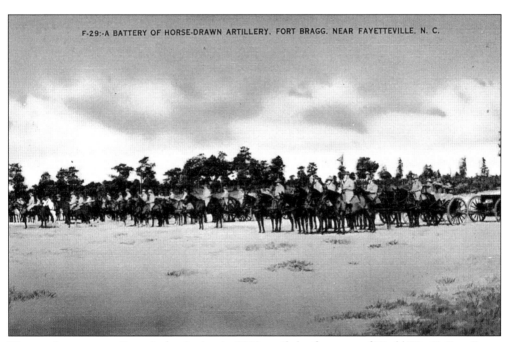

F-29:-A BATTERY OF HORSE-DRAWN ARTILLERY, FORT BRAGG, NEAR FAYETTEVILLE, N. C.

HORSE ARTILLERY. From its beginning in 1919 until the first year of World War II, Fort Bragg was home to units of "horse artillery." This well-known view from the early 1930s depicts a battery probably of the of 83rd Field Artillery. There is a misnomer in this picture, however. The animals in the picture are actually Army mules, which were used most frequently in the teams that pulled the field artillery guns and their caissons. (Courtesy of Larry Tew.)

MILITARY MUSCLE. Fort Bragg, home of the airborne and the Green Berets, is a military city of more than 44,000 active-duty men and women in uniform. Its architecture ranges from 70-year-old structures of the "old post" to modern high-rise classrooms.

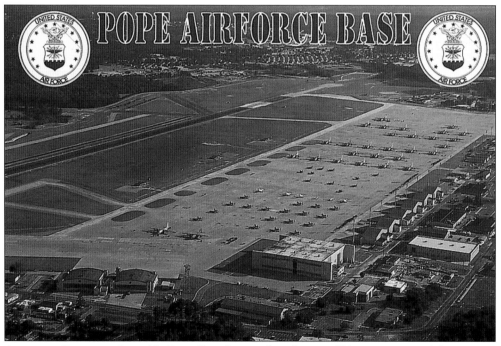

AVIATION PIONEER. Pope Air Force Base is a modern home of big transports and fast support aircraft, with acres of hard runways and loading areas. It began in 1919 as a dirt field where "Flying Jenny" two-seaters dodged deer on takeoffs and landings. (Courtesy of Roy Parker Jr.)

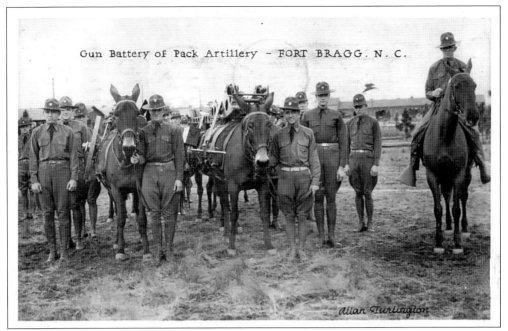

ANIMAL KINGDOM. The glory days of horse-drawn artillery was coming to a close when this 1940 card was published by Sgt. H. Allen Turlington, a noted freelance military photographer at Fort Bragg. But the Army mule and the Army horse were always ready to pose for a picture, as were the horse artillerymen in their crisp campaign hats. (Courtesy of Roy Parker Jr.)

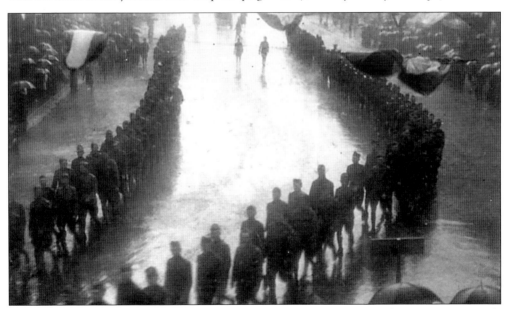

FIRST PARADE. This shadowy view, probably in May of 1919, shows the first Hay Street parade ever marched by soldiers from Fort Bragg, then Camp Bragg. The artillery post was only a few months old when this rain-soaked event took place. The occasion was to honor local men recently returned recently from the battlefields of World War I in France. (Courtesy of Roy Parker Jr.)

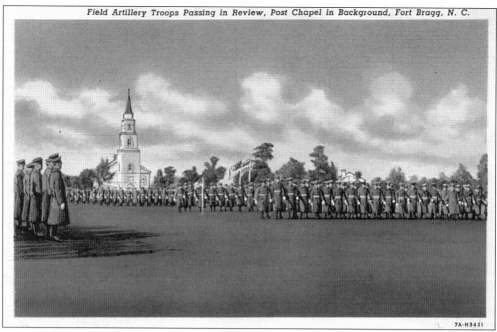

7A-H3431

PARADE GROUND. The post parade ground was the centerpiece of the 1930s post at Fort Bragg. With the post chapel in the background, these marchers step out on what is undoubtedly a winter a day, as they are dressed in full overcoats. (Courtesy of Roy Parker Jr.)

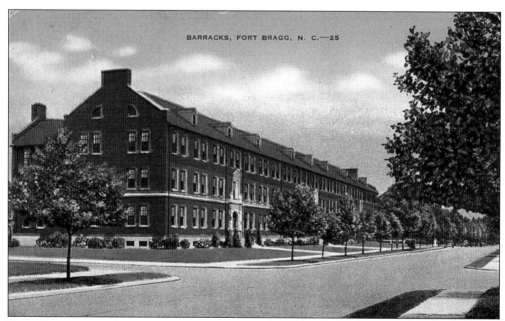

BARRACKS, FORT BRAGG, N. C.—25

FIRST BARRACKS. The 1930 building program that transformed Fort Bragg's World War I wooden buildings into a permanent military cantonment included this handsome row of barracks along the north side of Macomb Street. Each section housed a battalion of artillerymen. They are now used as offices. This late 1930s view is from a series by Army photographer, Sgt. H.A. Turlington. (Courtesy of Larry Tew.)

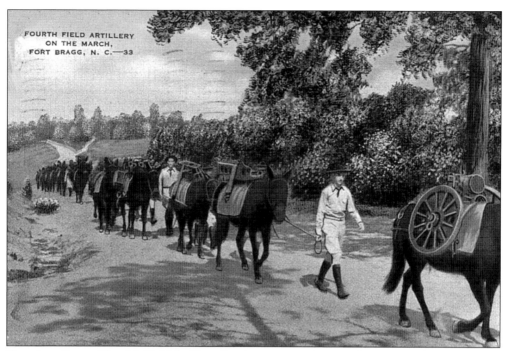

THE 4TH FIELD. The 4th Field Artillery Regiment was unique to the Army in the years before World War II. It was the "pack artillery." Its 75-millimeter cannons were disassembled and transported—the Army word was "packed"—on Army mules. Some pack units existed into World War II and saw action in Italy and the Pacific. (Courtesy of Clarence Winstead.)

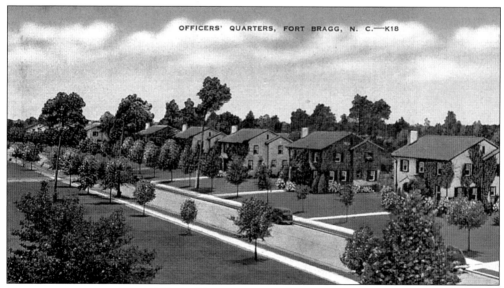

OFFICERS' QUARTERS, FORT BRAGG, N. C.—K18

OFFICER COUNTRY. The 1930s building program offered handsome new quarters for officers with families. The architectural design of gray stucco and red tile roofing was standard throughout all family housing areas on the post, which by 1940 was described proudly as "the largest artillery post in the world, known as a North Carolina beauty spot." The small trees in this early view are today great alleys of mature trees. (Courtesy of Larry Tew.)

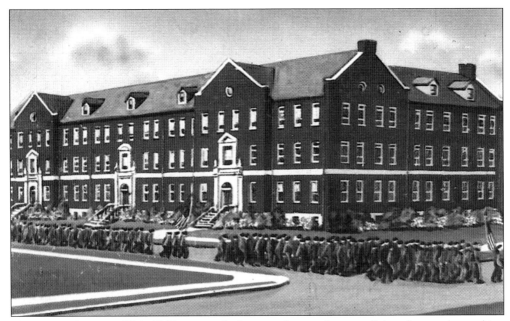

MORNING PARADE. This 1930s scene depicts a column of troops flying flags and marching along Macomb Street with the 1930 permanent barracks in the background. The three-story brick buildings housed a full battalion of artillerymen. In future years, most would be converted to offices, and all of the post Military Police still live in one of them. (Courtesy of Larry Tew.)

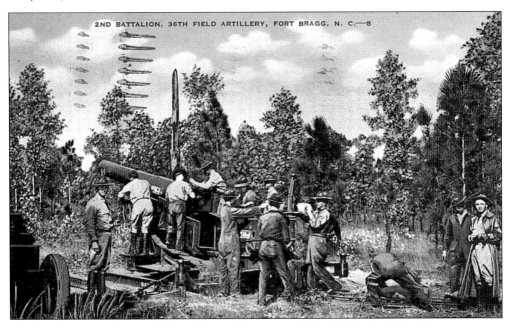

BIGGEST GUN. In the arsenal of artillery at Fort Bragg in the 1930s, the 240-millimeter cannon was the monster of them all. This famous 1937 picture depicts the 2nd Battalion of the 36th Field Artillery Regiment preparing to load and fire. The big guns were transported by tractors and assembled in the field. (Courtesy of Larry Tew.)

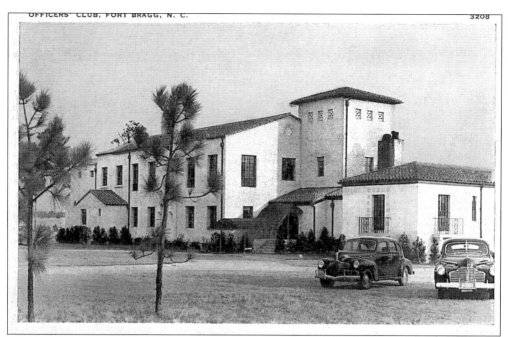

OFFICERS' CLUB. Designed like a Southwestern hacienda, the Officers' Club and its adjoining golf course complemented the new housing areas for officers of the 1930s building program that gave Fort Bragg the look of a permanent post. The design was not a mistake. The Army saved costs by using the same plans for Bragg that originally were drawn for posts in Texas and Oklahoma. (Courtesy of Larry Tew.)

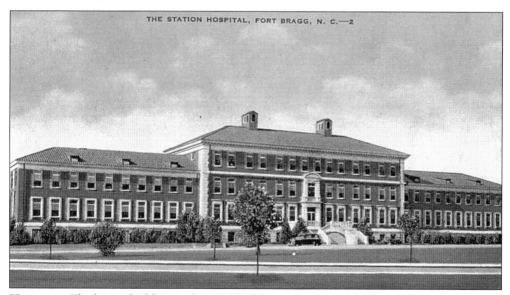

THE STATION HOSPITAL, FORT BRAGG, N. C.—2

HOSPITAL. The largest building in the 1930 building program was the imposing Station Hospital at the intersection of Macomb and Armistead Streets This postcard from the late 1930s is from a series taken by a popular post photographer, Sgt. H.A. Turlington. This structure would be replaced by a World War II Station Hospital and would be converted to headquarters of the post and of the XVIII Airborne Corps. (Courtesy of Larry Tew.)

107

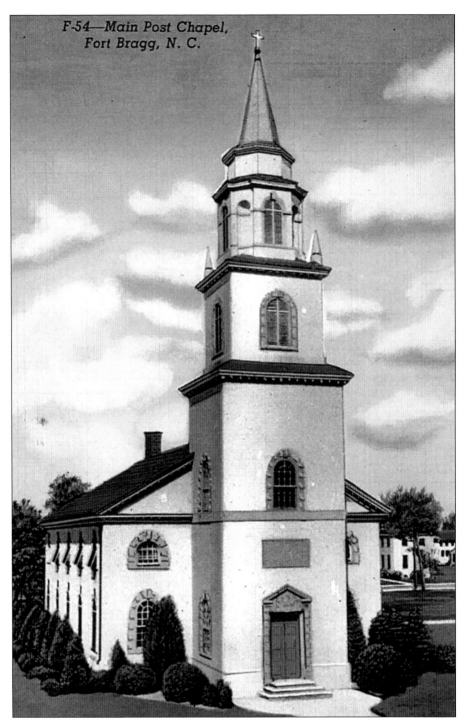

POST CHAPEL. The handsome post chapel built in the 1930 program continues to serve as a busy place for formal weddings and a full schedule of services. This early view of the chapel was published by Carolina News of Fayetteville from an enhanced photograph taken by the U.S. Army Signal Corps. (Courtesy of Larry Tew.)

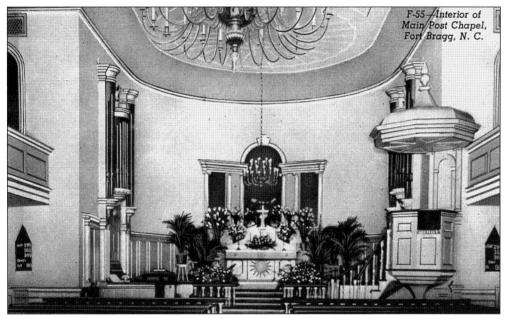

CHAPEL INTERIOR. The interior decor of the 1930 Main Post Chapel is decidedly "high church," although services of every denomination are held there. In the 1920s and 1930s peacetime Army, a large percentage of the personnel were Roman Catholic, including a commanding general named Manus McCloskey. (Courtesy of Clarence Winstead.)

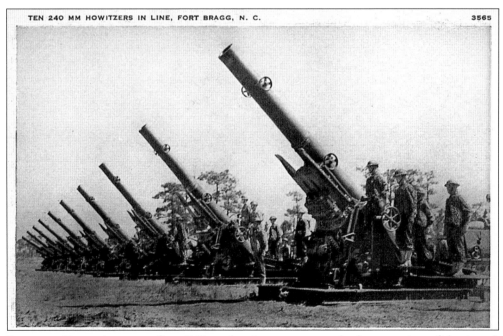

LARGEST GUNS. An array of ten 240mm howitzers represented a large portion of the Army's heaviest artillery in the 1930s. The description on this card reads "Weight 20 and a half tons. Range 12 miles. Weight of projectile 345 pounds. Record for placing in firing position 45 minutes. Transported in four pieces." (Courtesy of Roy Parker Jr.)

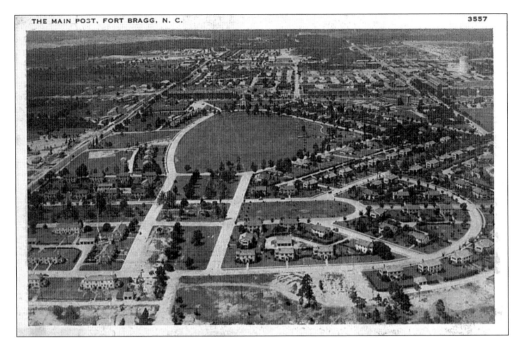

OFFICER COUNTRY. This aerial looks north on the formal layout of the 1930 officers' quarters area, with Reilly Road on the left and the parade ground in the upper center. The design reflected the Beaux Art concept of urban planning laid alongside an earlier chevron design. (Courtesy of Clarence Winstead.)

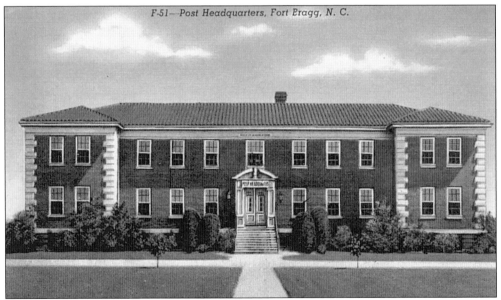

F-51—Post Headquarters, Fort Bragg, N. C.

HEADQUARTERS. The headquarters of the 13th Artillery Brigade was the centerpiece of the early 1930s building program that transformed Fort Bragg from an array of temporary wooden buildings to a permanent post. The building in the standard architectural design of the program was just off Macomb Street between Hamilton and Knox Streets. (Courtesy of Larry Tew.)

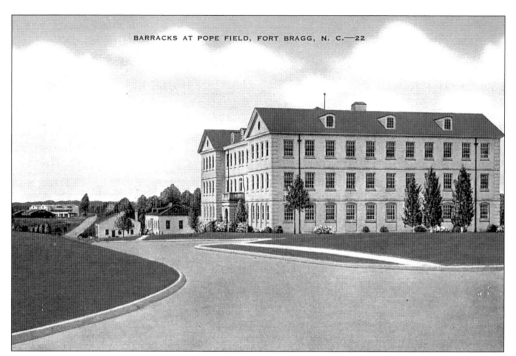

THE 1930S EXPANSION. The barracks for Air Corps Troops went up in the early 1930s as Pope Field shared in the building program that transformed the old World War I post to a handsome array of permanent structures. (Courtesy of Larry Tew.)

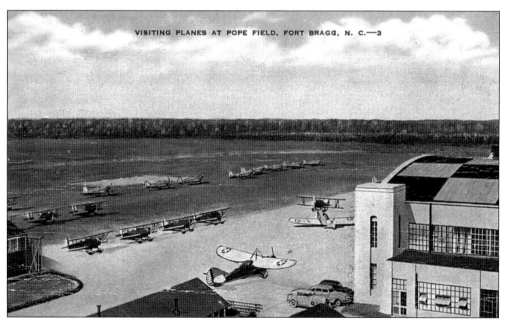

POPE FIELD. This view taken by Sgt. H.A. Turlington is among the most familiar depictions of Pope Field in the 1930s. The lineup along the flight line includes both biplanes and single-wing aircraft, reflecting the fact that in this period Pope was largely used as a stopover transient field by Air Corps planes. (Courtesy of Larry Tew.)

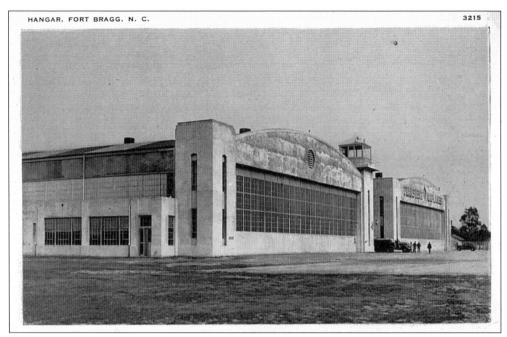

MODERN HANGERS. Pope Field got these new hangers in the 1930s, replacing wooden structures that had served since the first aviators arrived in the first weeks of 1919. The large letters on the far hanger say "Transient Aircraft," reflecting Pope's role as a popular stopping place for military aircraft on the East Coast.

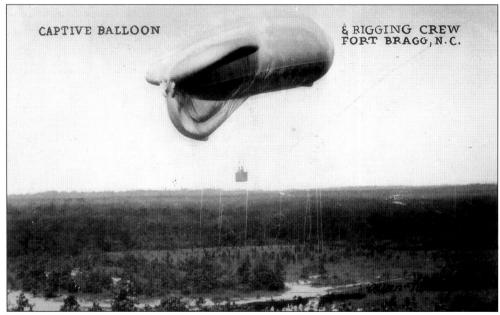

CAPTIVE BALLOON

& RIGGING CREW
FORT BRAGG, N. C.

THE SAUSAGE. Observation balloons were the eyes of the artillery and Pope Field was a center for Army balloon service as far back as the 1920s, when the sausage-shaped bags floated over firing ranges. This 1930s photo was taken by Sgt. H. Allen Turlington and published by the Fort Bragg Post Exchange. (Courtesy of Roy Parker Jr.)

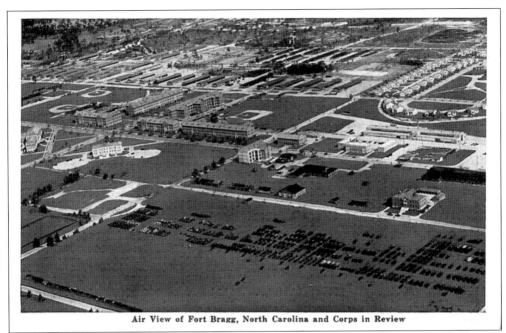

Air View of Fort Bragg, North Carolina and Corps in Review

AERIAL VIEW. Taken in 1937, this aerial presents Fort Bragg in its pre-war prime before the World War II expansion in the fall of 1940. The corps drawn up on the plain known as the polo field includes practically the entire post population. The curving streets in the upper right are an array of quarters for the families of enlisted men, an area known today as "Bastogne Acres." (Courtesy of Clarence Winstead.)

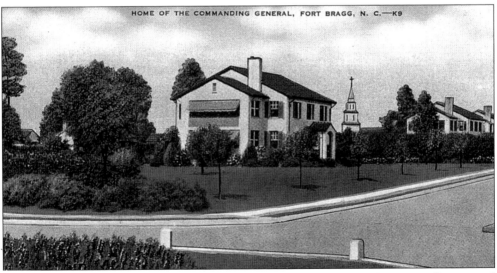

HOME OF THE COMMANDING GENERAL, FORT BRAGG, N. C.—K9

HIGH COMMAND. The 1930 house assigned as quarters for Fort Bragg's commanding general is numbered One Dyer. The street is named for Alexander Brydie Dyer, who was Chief of Ordinance of the Union Army in the Civil War and at one time a commandant of the U.S. Arsenal in antebellum Fayetteville. The two-story structure is officially of Spanish Colonial Revival design. This early 1930s view looks over from the circle at the foot of Randolph Street. The flowers have been replaced by the Iron Mike statue.

113

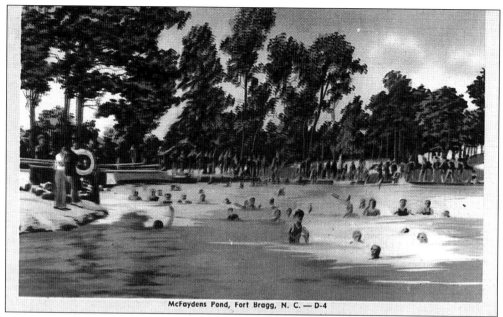

MCFAYDENS. From Fort Bragg's first days, the pond in the pinewoods named for the 18th-century family was a recreational spot for soldiers and their families. By the time of this view published by Carolina News of Fayetteville in the late 1930s, it was fully developed as a swimming spot, complete with a diving board. (Courtesy of Larry Tew.)

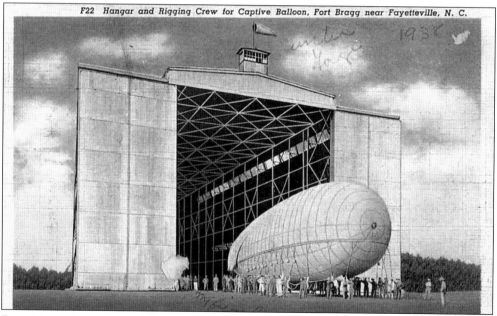

F22 Hangar and Rigging Crew for Captive Balloon, Fort Bragg near Fayetteville, N. C.

BALLOONS. Lighter-than-air balloons were colorful Army equipment in the years prior to World War II. Fort Bragg was home of a major unit, the 2nd Balloon Squadron. Its "sausages" were motorized with an open-air cockpit and engine slung beneath the bag. This captive balloon coming out of the Pope Field 1930s balloon hanger was tethered to the ground and carried observation personnel aloft in a basket. (Courtesy of Clarence Winstead.)

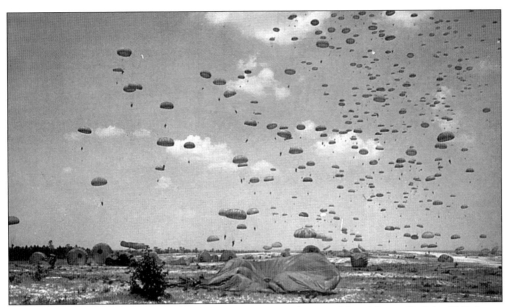

PARACHUTE ARMY. Since 1942, Fort Bragg has been "home of the airborne" of the U.S. Army. This 1960s view of a jump involving several hundred paratroopers particularly illustrates the typical terrain of the many sandy jump zones on the big military reservation. The jumpers are members of the 82nd Airborne Division, known as America's Guard of Honor. (Courtesy of Larry Tew.)

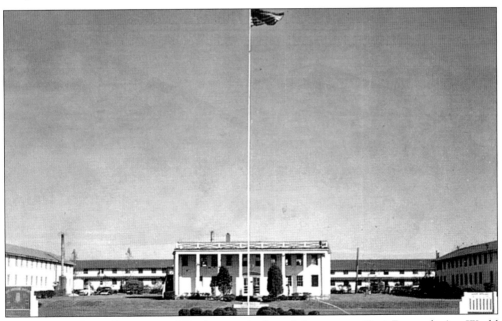

ARTILLERY HIGH COMMAND. The largest single training area at Fort Bragg during World War II was the Field Artillery Replacement Training Center, which opened in 1941. This building was its headquarters. By 1956, it was headquarters for the artillery of the 82nd Airborne Division, later of the 1st Corps Support Command. It was demolished in the 1980s. (Courtesy of Roy Parker Jr.)

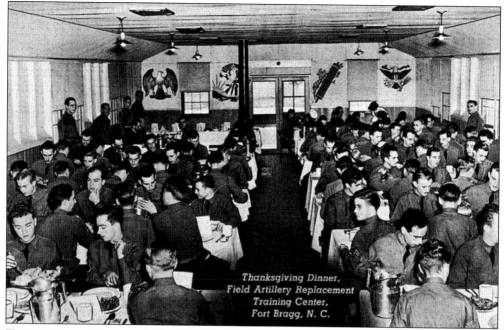

Thanksgiving Dinner,
Field Artillery Replacement
Training Center,
Fort Bragg, N. C.

THANKSGIVING. The mess halls of the Field Artillery Replacement Center became banquet halls on holidays. Army cooks traditionally prepared full course Thanksgiving and Christmas meals, with turkey and all the trimmings. The pot-bellied stove was a welcome sight on chilly days. (Courtesy of Roy Parker Jr.)

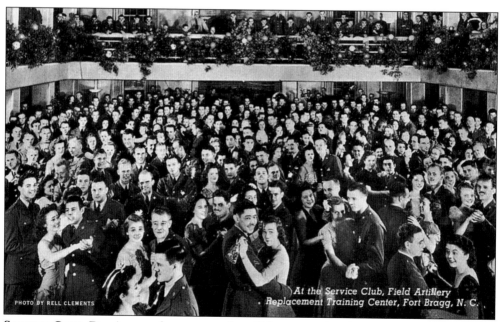

PHOTO BY RELL CLEMENTS

At the Service Club, Field Artillery
Replacement Training Center, Fort Bragg, N. C.

SERVICE CLUB. Dancing was the most popular off-duty recreation for soldiers during World War II. The Service Center at the Field Artillery Replacement Center had a full schedule of dances, with dance partners bused in from Fayetteville and other cities in North Carolina. (Courtesy of Roy Parker Jr.)

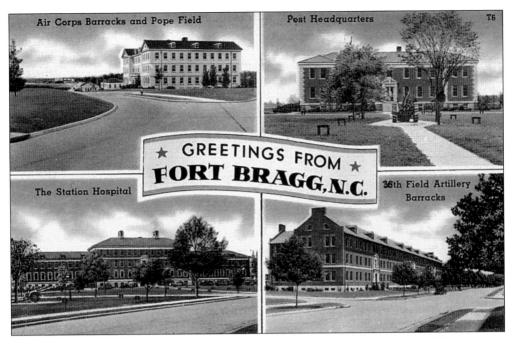

WAR GREETINGS. This card was among the first that the thousands of new soldiers arriving at Fort Bragg in 1940 could send home. It depicts four of the 1930s buildings, including the Station Hospital in the lower left, which was soon replaced by a larger medical center and is used today as the headquarters of the 18th Airborne Corps and Fort Bragg. (Courtesy of Roy Parker Jr.)

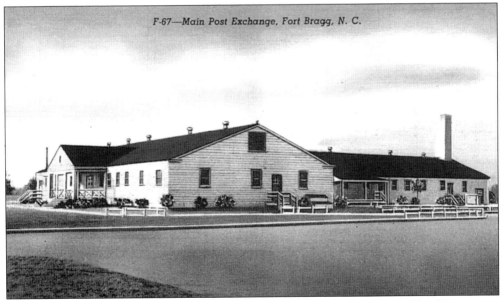

POST EXCHANGE. The World War II expansion of the post included buildings like this one near the Main Post area, which, by the 1960s was renovated as the Main Post Exchange. Today, modern on-post shopping centers still bear the name of post exchange, the old name for an Army-style department store. (Courtesy of Larry Tew.)

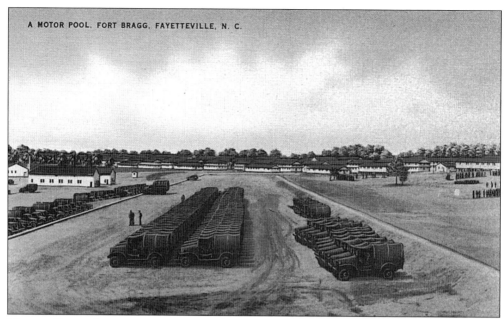

A MOTOR POOL, FORT BRAGG, FAYETTEVILLE, N. C.

MOTOR POOL. A rare Fort Bragg scene from World War II is this view in what is probably the Ninth Division area, where that famous division trained from 1940 until it went overseas in late 1942 to participate in the Allied invasion of North Africa. The vehicles appear to be early-model Jeeps with a canopy over the back seat. (Courtesy of Roy Parker Jr.)

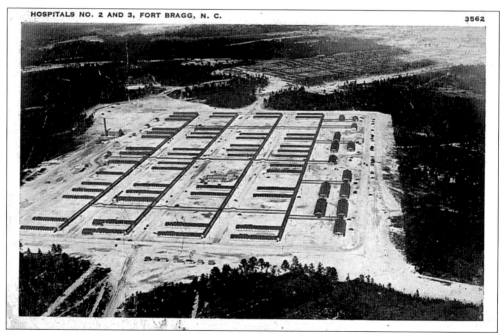

HOSPITALS NO. 2 AND 3, FORT BRAGG, N. C. 3562

HOSPITAL. The construction program of 1940–1941 that made Fort Bragg the largest Army post in time for World War II, included this array of single-story wards, warehouses, and support facilities officially known as Hospitals 2 and 3. The medical complex had its own utilities system and could handle 3,000 patients at one time. (Courtesy of Larry Tew.)

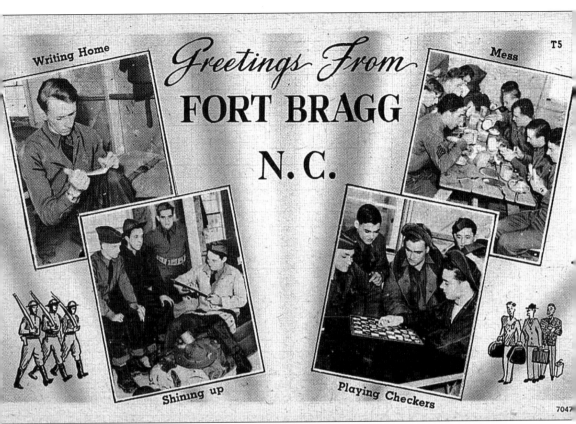

WRITING HOME. This card from 1941 seems specifically designed to encourage a new soldier to write home, while the cozy scenes of checker–playing and mess call would reassure the folks back home that Fort Bragg was a good place for loved ones to begin life in the Army. (Courtesy of Larry Tew.)

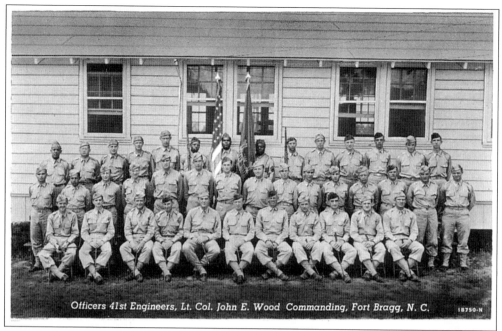

Officers 41st Engineers, Lt. Col. John E. Wood Commanding, Fort Bragg, N. C.

THE 41ST ENGINEERS. Known as the singing engineers, the 41st Engineer Regiment (Colored) was a famous unit at Fort Bragg in 1941. While its enlisted men were African American, the officers were all white, except for the chaplain. The only other African Americans in this group portrait are the four enlisted men of the color guard. (Courtesy of Roy Parker Jr.)

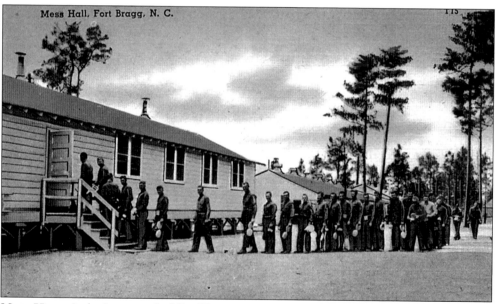

Mess Hall, Fort Bragg, N. C.

MESS HALL. A classic scene of soldier life at Fort Bragg during World War II is this depiction of the chow line at a mess hall, the Army name for a dining room. Typically, each company of 200 to 300 men had its own mess hall. Each man is carrying his metal mess kit, aluminum plate, and cup. (Courtesy of Clarence Winstead.)

STATION HOSPITAL. As Fort Bragg grew to become the Army's largest World War II cantonment, the temporary buildings of the new Station Hospital occupied a huge site west of Reilly Road across from the old post officers' country. The single-story wards were connected by ribbons of covered walkways. This postwar view shows the headquarters building of the complex with the typical temporary World War II construction. (Courtesy of Larry Tew.)

Entrance to James Gabriel Demonstration Area

GREEN BERET. Beginning in the 1960s the famous Green Berets, soldiers of the Special Forces, showed off their skills at this noted woodland site known as the James Gabriel Demonstration Area off Gruber Road near the enlisted men's golf course. Visiting politicians and journalists joined inspecting officers to see the demonstrations.

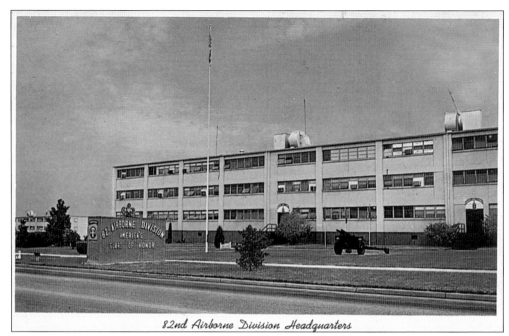

82nd Airborne Division Headquarters

THE 82ND HEADQUARTERS. The centerpiece of the 1950s building program along new Gruber Road and Ardennes Street was the three-story headquarters building for the 82nd Airborne C Division. This building served until the 1980s, when the division command post moved across Gruber Road into the building originally housing the Noncommissioned Officers' Club. (Courtesy of Larry Tew.)

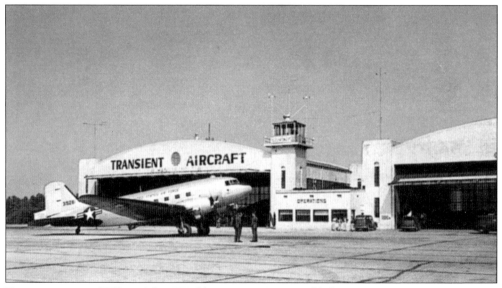

POPE IN THE 1950S. After World War II, Pope Field became Pope Air Force Base, headquarters of the Ninth Air Force, its prewar hangers now a stopping-point for staff and commanders from throughout the eastern United States. A famous plane of the war, the C-47, is now dressed up in silver and bears the new insignia of the USAF. (Courtesy of Clarence Winstead.)

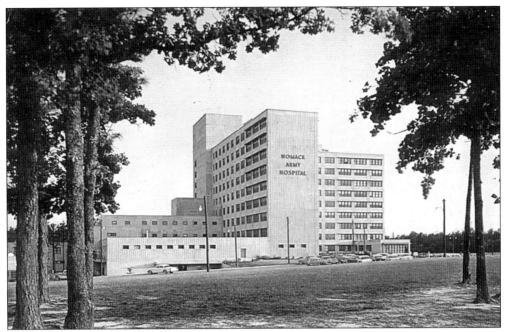

ARMY HOSPITAL. Womack Army Hospital was built after the Korean War in 1950–1953, and it replaced the sprawling Station Hospital of World War II. The nine-story structure remained the principal medical facility on Fort Bragg for over 40 years. Named in honor of PFC Bryant Womack, an Army medic killed in the Korean War, it is being converted to other uses. (Courtesy of Larry Tew.)

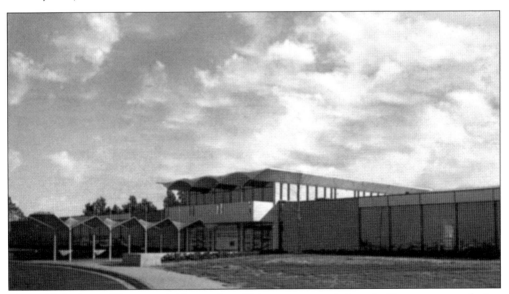

THE NCO CLUB. The new clubhouse for off-duty noncommissioned officers went up during the building program after the Korean War in the 1950s. On an imposing sand hill just off new Gruber Road at Gola Street, the club looked down on the curving array of barracks that are home for the men of the 82nd Airborne Division. Today, it is the headquarters building for the division. (Courtesy of Clarence Winstead.).

AIRDROP. In time for the Korean War in 1950, the airborne Army and the Air Force developed airplanes big enough to carry equipment like the famous Jeep, as well as artillery pieces, and drop them alongside the jumping paratroopers. This 1960s view demonstrates the technique of loading equipment onto shock-absorbing material, a method called palletizing. (Courtesy of Larry Tew.)

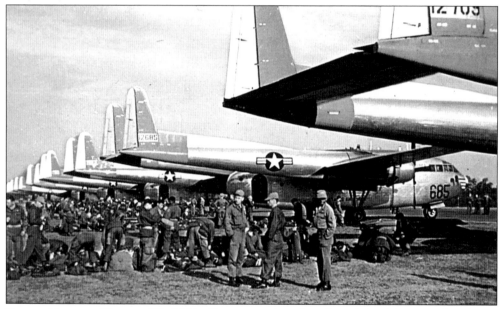

FLYING BOXCAR. The post-World War II transport plane that allowed the airborne to drop heavy equipment out of a rear bay was the twin-boomed C-119, known as the "Flying Boxcar." In this view from the 1960s, Fort Bragg paratroopers are preparing to board a lineup of C-119 aircraft for a mass jump into the drop zones on the western end of the reservation. (Courtesy of Larry Tew.)

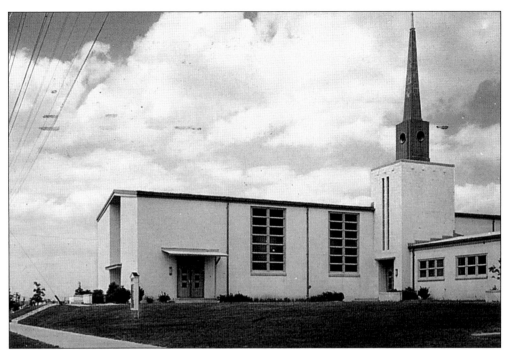

AIRBORNE CHAPEL. Built in the 1950s expansion along new Ardennes Street and Gruber Road, the 82nd Airborne Division chapel on Ardennes continues to serve troops living in the dozens of barracks along Gruber. It is the principal chapel for funerals and memorial services for paratroopers. (Courtesy of Larry Tew.)

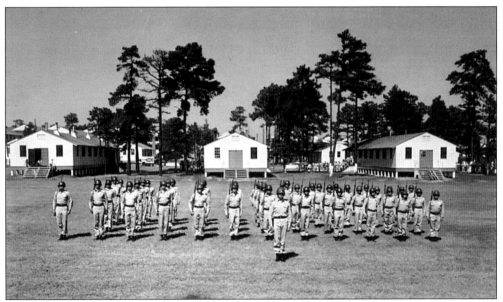

POSTWAR PARADE. Posed in front of typical World War II barracks in the Old Division area of Fort Bragg, this platoon of postwar paratroopers in crisp formation prepares for either an inspection or a parade. They wear the summer dress uniform of the decades just after World War II. (Courtesy of Larry Tew.)

MEMORIAL PLAZA. The Green Beret Statue is the centerpiece of the memorial plaza across from the John F. Kennedy Institute for Military Assistance. It depicts a typical Special Forces soldier of the Vietnam War period. (Courtesy of Roy Parker Jr.)

Chapel, John F. Kennedy Center for Special Warfare

GREEN BERET CHAPEL. Using the name for the Green Beret training organization, the Chapel of the John F. Kennedy Center for Special Warfare is the site of memorial services for the men of the Special Forces killed in action in the far corners of the globe. (Courtesy of Larry Tew.)

THE 82ND MUSEUM. Displays depicting the nearly 85-year history of the 82nd Airborne Division, from its service as a infantry division in France in World War I through recent duties in the Balkans are featured in the 82nd Division Memorial Museum on Ardennes Street. The grounds of the museum display artillery pieces and an array of aircraft used by paratroopers in combat jumps since World War II. (Courtesy of Larry Tew.)

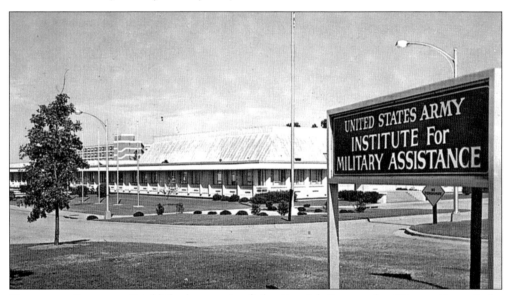

KENNEDY SCHOOL. Established as part of the Special Forces, the "Green Berets," the U.S. Army Institute for Military Assistance trains military personnel from friendly countries where U.S. forces could operate in the future. It is officially named for President John F. Kennedy, who in the early 1960s encouraged the Special Forces concept. (Courtesy of Clarence Winstead.)

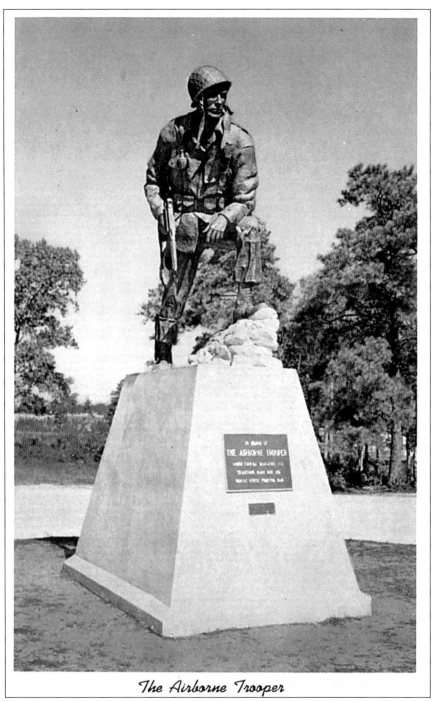

The Airborne Trooper

IRON MIKE. Among the first examples of military statuary erected on Fort Bragg is "Iron Mike," officially known as The Airborne Trooper. Made of plastic, the larger-than-life stature of a World War II paratrooper stood at the Bragg Boulevard entrance to the post for more than 25 years before it was moved to a circle in front of the commanding officer's residence at the intersection of Randolph and Armistead Streets.